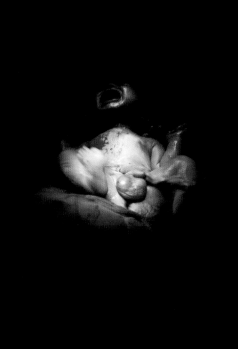

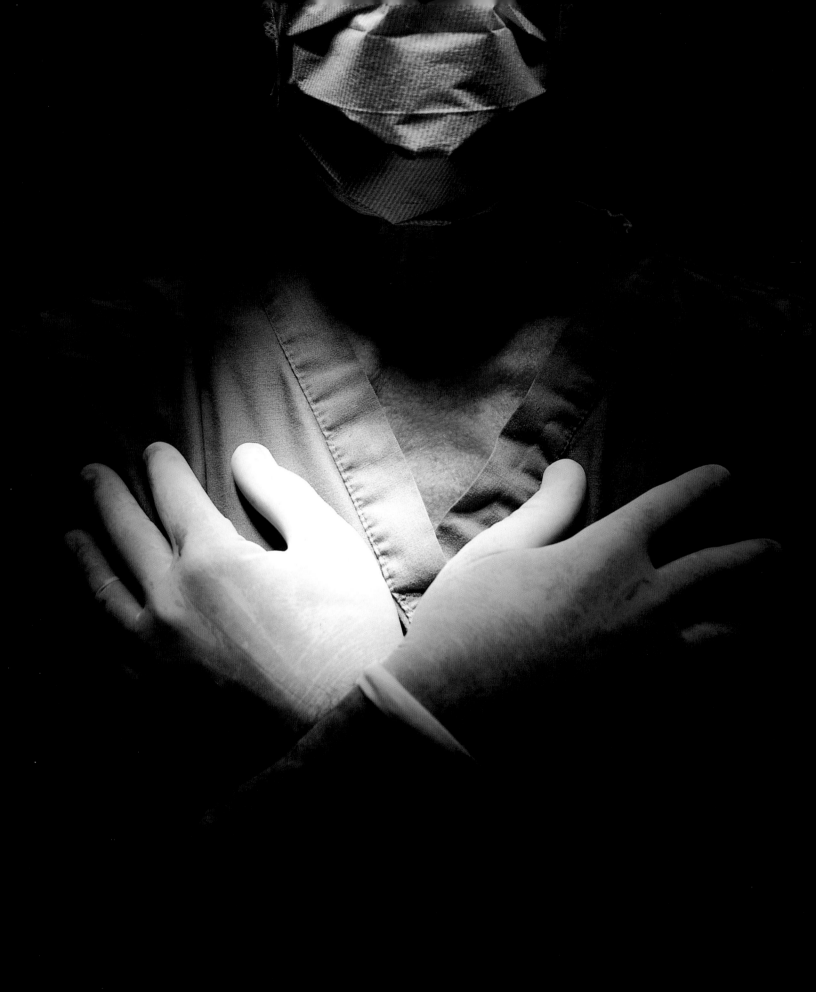

THE
SACRED
HEART

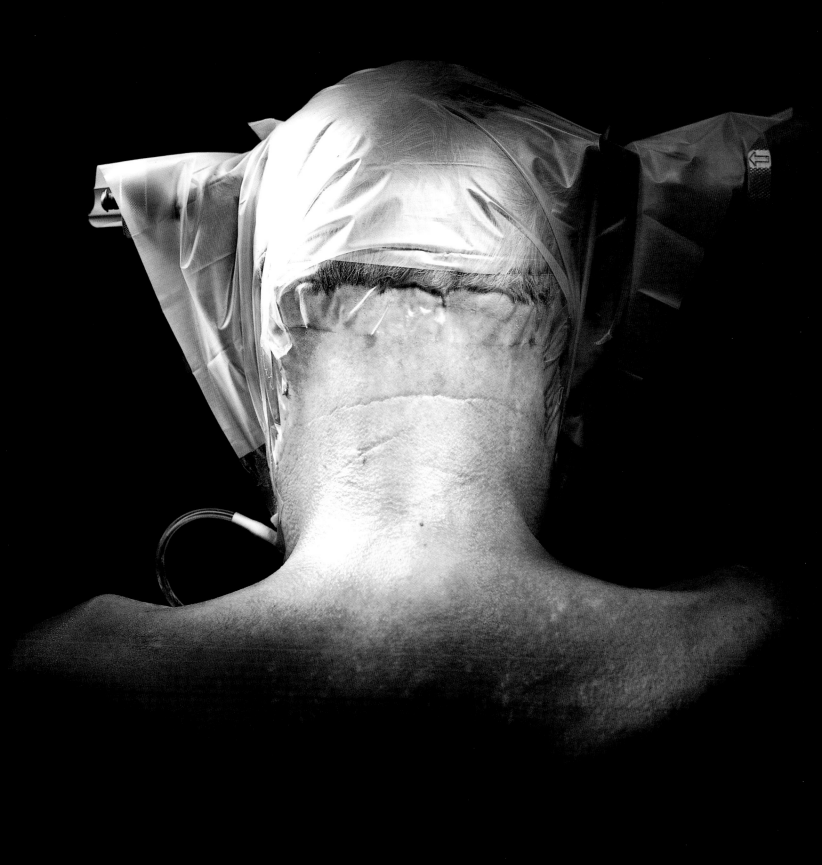

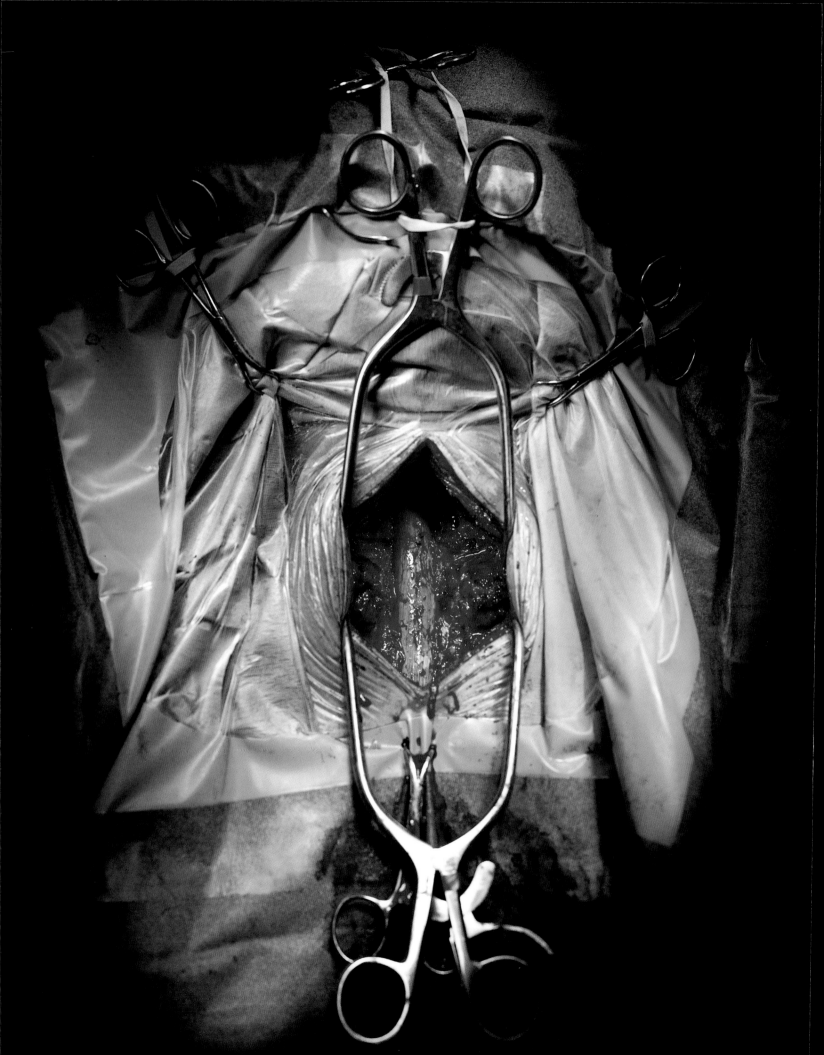

THE SACRED HEART

INTRODUCTION BY RICHARD SELZER, M.D.
AFTERWORD BY A.D. COLEMAN

AN ATLAS OF THE BODY SEEN THROUGH INVASIVE SURGERY MAX AGUILERA-HELLWEG

A BULFINCH PRESS BOOK
LITTLE, BROWN AND COMPANY · BOSTON NEW YORK TORONTO LONDON

First Edition

Library of Congress Cataloging-in-Publication Data

Aguilera-Hellweg, Max.

The sacred heart : an atlas of the body seen through invasive surgery / Max Aguilera-Hellweg;

introduction by Richard Selzer; afterword by A. D. Coleman.

p. cm.

"A Bulfinch Press book."

ISBN 0-8212-2377-1

1. Surgery—Pictorial works. 2. Surgery, Operative.

I. Title.

RD41. A38 1997

617'.91'0222—dc21

97-5910

Bulfinch Press is an imprint and trademark of Little, Brown and Company (Inc.)

Published simultaneously in Canada by Little, Brown & Company (Canada) Limited

Design by Tony Lane

PRINTED IN HONG KONG

This book is dedicated
to my father, who taught me
that I could accomplish
anything I set my heart to;
and to my mother,
who has supported me
ever since.

M. A. H.

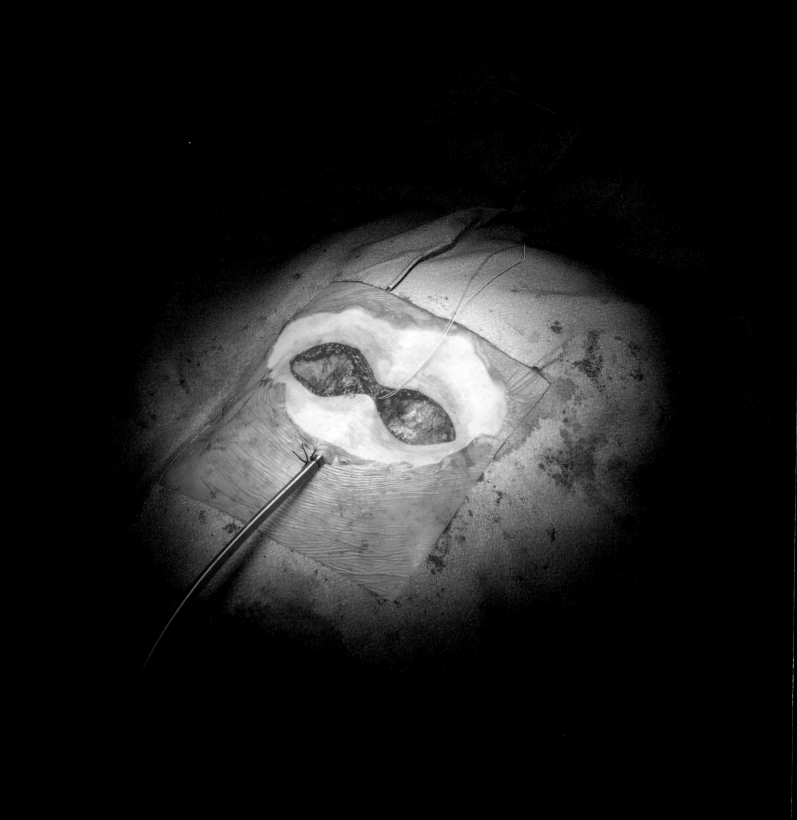

CONTENTS

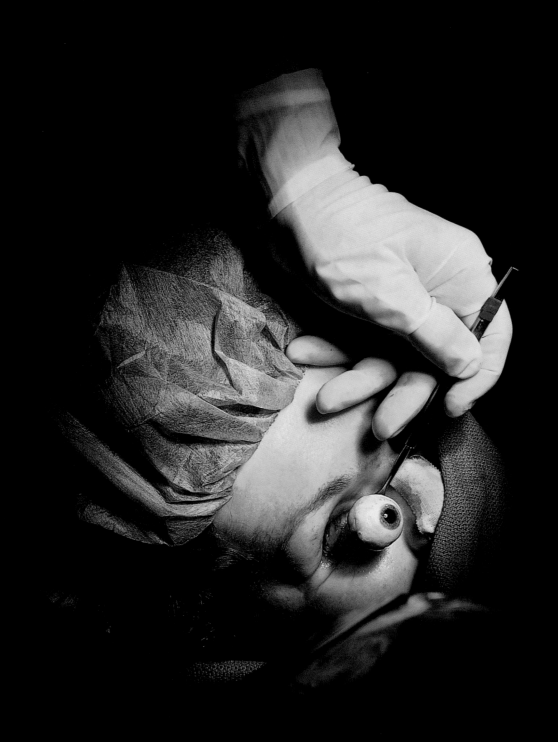

INTRODUCTION
FLESH HOLDS THE TRUTH, MORTALITY

Richard Selzer, M.D.

"T is so appalling — it exhilarates —" wrote Emily Dickinson. Here is the terrifying truth that we have all along striven to hide from view — with clothing, makeup, beards — at last exposed. Like the surgeon, the photographer slashes open the body of his fellow man, removes his eyes, empties his abdomen of organs, hangs him up on a hook, holding up to the light all the body's palpitating treasures, sending a burst of light into its remotest depths. Like the surgeon, the photographer seeks to reveal a truth. We gaze at these chilling pictures and we are led into contemplation of the fragility and the toughness of the human body.

I have some hesitation in introducing these photographs to an innocent laity. Perhaps these things should remain the secrets of the priesthood of surgery. Perhaps it is a violation of a taboo to show them. It is not the beautiful or the sublime that is celebrated here; it is the forbidden, the truth incarnate before which even a physician's heart may quail. Anton Chekhov, doctor and writer, cried out in despair during the dissection of a cadaver: "Where is the soul in all of this?" But we must admit to whatever exists, deny nothing. Only then can we achieve enlightenment. Leonardo da Vinci, scientist, artist, vegetarian, also dissected the bodies of the newly dead — forty of them, in the heat of Florence, Italy. Each time, he located beauty and truth and reported it back to the world in his great anatomical drawings.

With the click of his shutter, the photographer hopes to transform his subject — be it a normal heart, a liver, or some hideous, pathological distortion — into a sacred icon. His will be a transforming vision, like that of a prophet. The photographer would restore the mythic to modern surgery! But surgery is devoid of the sacred. It has to be, or so the

surgeons insist. These photographs tell us what is in danger of being lost, that man sets great store by myths. We live by them. Through myth we can bypass the intellect, and free up the imagination, that bane of the technologist. In myth lies intuition and instinct. The artist who would lay open the events of the body for our interpretation is tracking down the prelogical. He is the enemy of science, a pagan. Let us look together at some of these works:

Among them is a woman or a girl, I think, whose eyelids have been sewn shut. There is something about the brow, the eyebrows, that makes me think so. Or is it the chador of towelage she is wearing? The lids are stitched so as to protect the eyes during facial reconstruction. It is a prudent measure. Perhaps, too, there is some protection for the surgeon as well, lest he see in those eyes something that will give pause — her terror or reproach?

The heart has only just been harvested for transplantation. *Harvest. Transplantation.* Soft words of husbandry and the soil implying fruition, growth. Our sensibilities would be offended by the more precise term — *evisceration*. The heart seems smaller than imagined and all but embedded in fat. Only a few islands of red muscle show, and the cut ends of the great vessels above. The harvested heart still beats, the way the heart of a dogfish, removed and dropped into a beaker of saline, will go on beating for up to eight hours. Is it alive? Or only technically so and giving but the appearance of life? Or is it in a state of virtual death? These are questions for the philosopher, the ethicist, not the surgeon. The freshly taken liver, too, lies in the palms of the surgeon, vulnerable but with all its powers of cleansing and manufacturing intact. Soon these organs will fill with new blood and pulsate. See how the incision through which the

13

heart has been removed has not been repaired cosmetically, as by a plastic surgeon, but is reefed up just to get the cavity closed.

The girl, we are told, has a parasite in her brain. It is cysticercosis. She has eaten partially cooked pork and become infested. The parasite has wriggled all the way to her brain. She is young, but what with her crooked teeth and poor complexion and the crown of stainless steel she is wearing, she does not look her best. Never mind, there is no place for embarrassment in the operating theater. Ten thousand years ago, a tribesfellow would have come upon her unconscious body. He would have taken one of his sharpest stones, a fleam, and bored a hole in her skull at the place where the shaman had told him the invader lay. No vise such as holds this girl's head, but the strong hands of another man to steady her. When the hole had been made, the ancient surgeon would have packed it with boar fat to lure the parasite so that he might grasp and pull it out. But now there is a stereotactic crown screwed into the skull. A CT scan has been done to plot longitude and latitude and so locate it. Same thing, almost. Wouldn't you say?

Pectus excavatum it is called. Sunken chest. The piracy took place before he was born. His ribs and sternum developed unequally so as to form a concavity in the front of his thorax, deep enough in some to press against the heart and great vessels. It is a curse handed down from father to son to grandson. This boy's chest is a maelstrom whirling down toward his most vital parts. We do not need his face to tell us how he feels. All of his anguish is expressed by the torso. Let the nipples be his eyes; let the surgical wound be a mouth open as if to howl. It is often so, that pain, rage, sorrow, will be transferred from the face to another part of the body, there to be portrayed all the more powerfully.

Look here! A man is hanging from the ceiling by a C-clamp attached to his skull. It is his spinal canal they are after. The vertebrae have enlarged to encroach upon the spinal cord. There is numbness, weakness, evidence of incipient paralysis. He, too, is wearing the uniform of his regiment — a headdress of towelage, something like Saran Wrap to cover his skin, a tube in the windpipe, and that stainless-steel crown. But there, on the back of his neck, at the place where he will be cut, are those creases, like hieroglyphs, written in a rare ink that has just been made visible by odd chemicals. A message from patient to doctor: *Primum non mihi nocere.* First, do not harm me. And here, in the next picture, through the incision, we see that the vertebrae have been chipped away, the spinal cord made comfortable in its canal.

And here is an abdomen from which the liver, spleen, pancreas, and kidneys have been harvested. It is a room emptied of furniture and swept with a broom.

The outrage of birth! This boy delivered by cesarean section, "untimely ripped" from his mother's womb, as Shakespeare said of Macduff. It seems an expulsion from Eden, what with the cool air abrading tender skin unprotected by amniotic fluid and vernix caseosa, the maternal smear. No rock-a-bye baby in the treetops for him. If he cries now, it is for his placental pillow. In time, he will cry for his blanket. It is what we have all endured, then repressed — the trauma of birth. Once again the photographer awakens our deepest anxieties.

And now, an eyeball is removed for its precious cornea. It is held out like something on the end of a stalk. Just behind, in the shadow, fringed by damp lashes, the empty socket. We do not gaze *into* this eye; we gaze *upon* it. In that change of prepositions there is revealed one of our most primitive fears — that of blindness. This enucleated eyeball reminds us of the punishment of Samson by the Philistines and the blinding of Oedipus by his own hand, and now at last we cannot keep from shuddering. There is irony in this as the whole purpose of the harvest is that someone who cannot, will see.

I have tried to hold up the lamp of language to these powerful photographs. They do not need elucidation. Words cannot come near the beauty and truth they convey. Like all fine art, they speak for themselves.

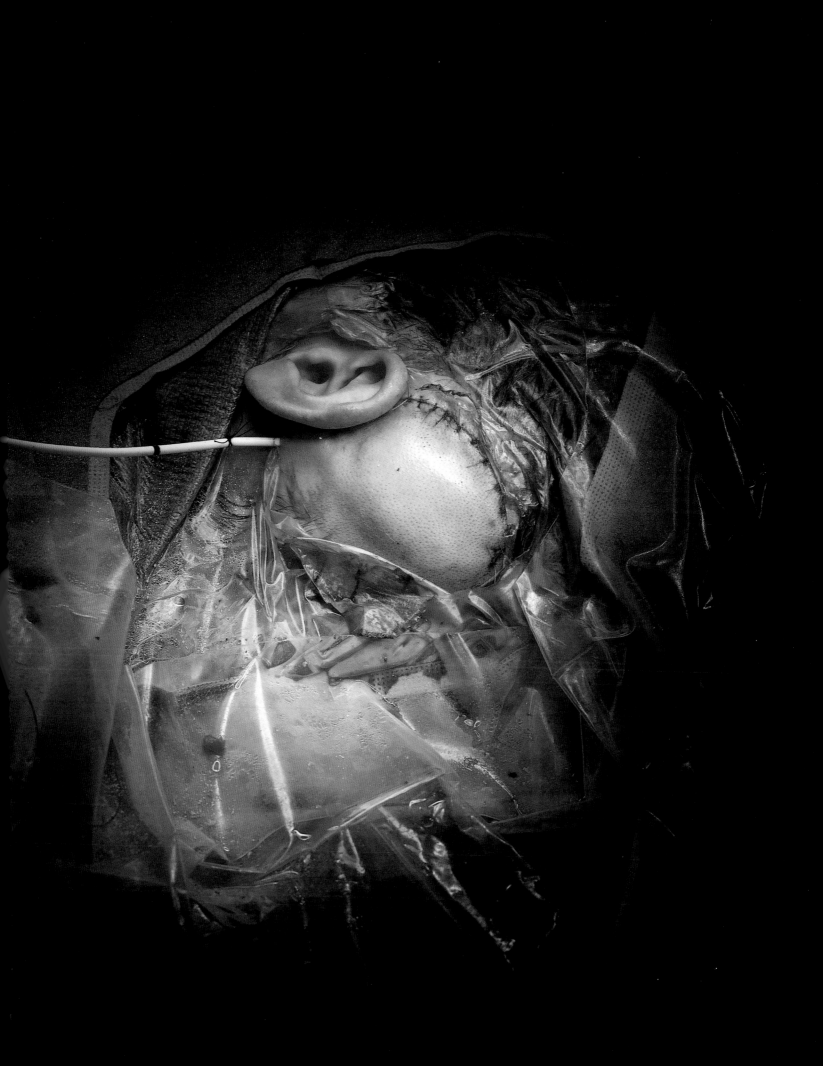

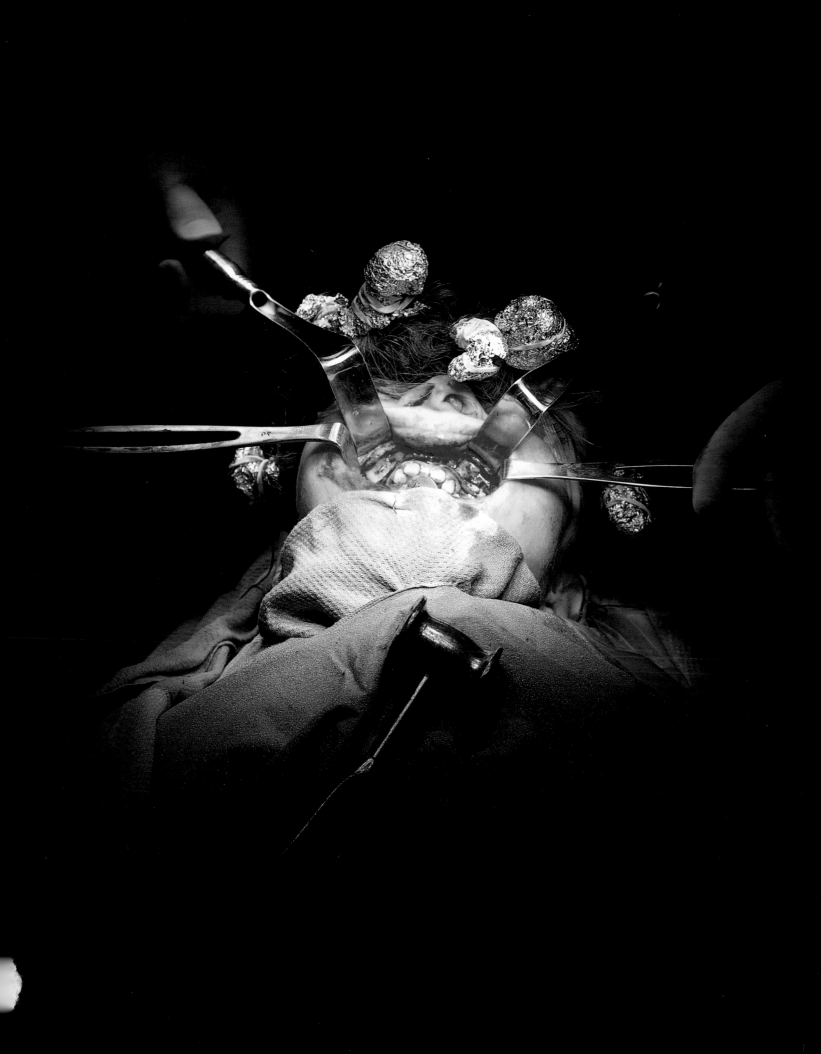

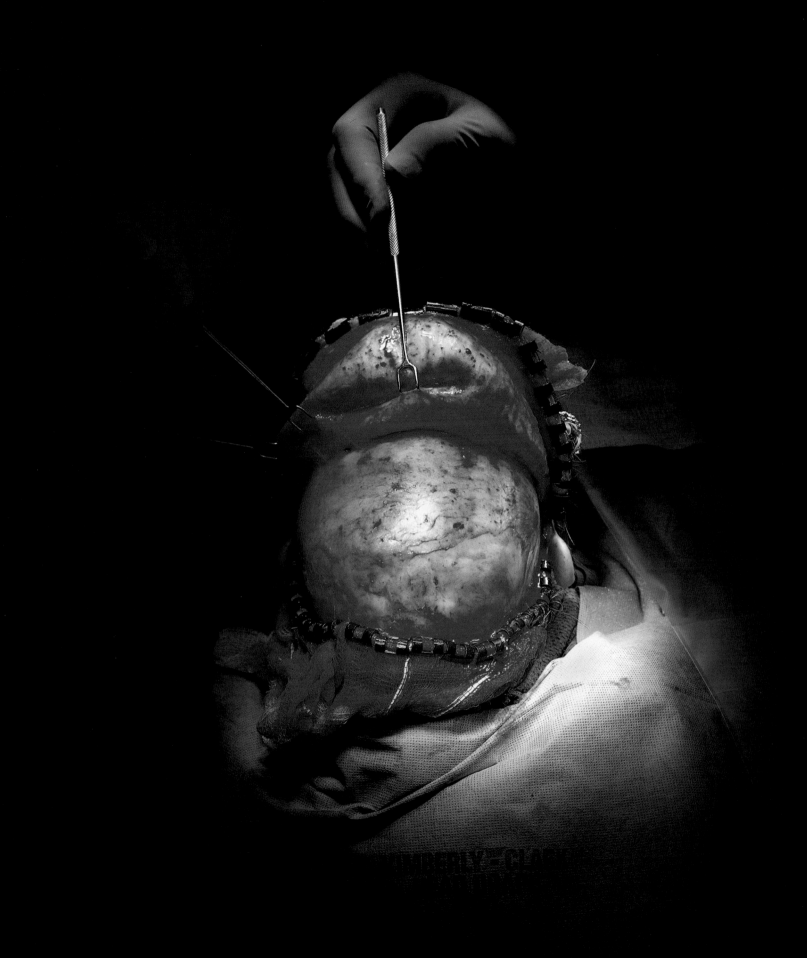

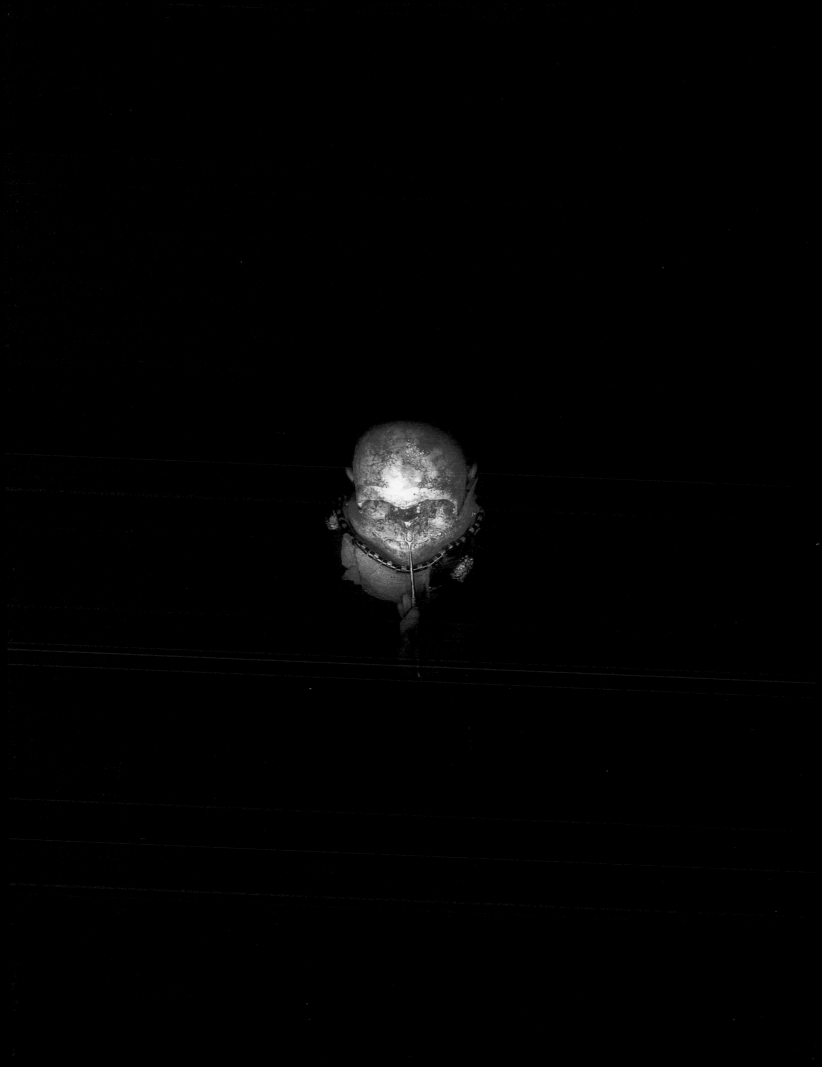

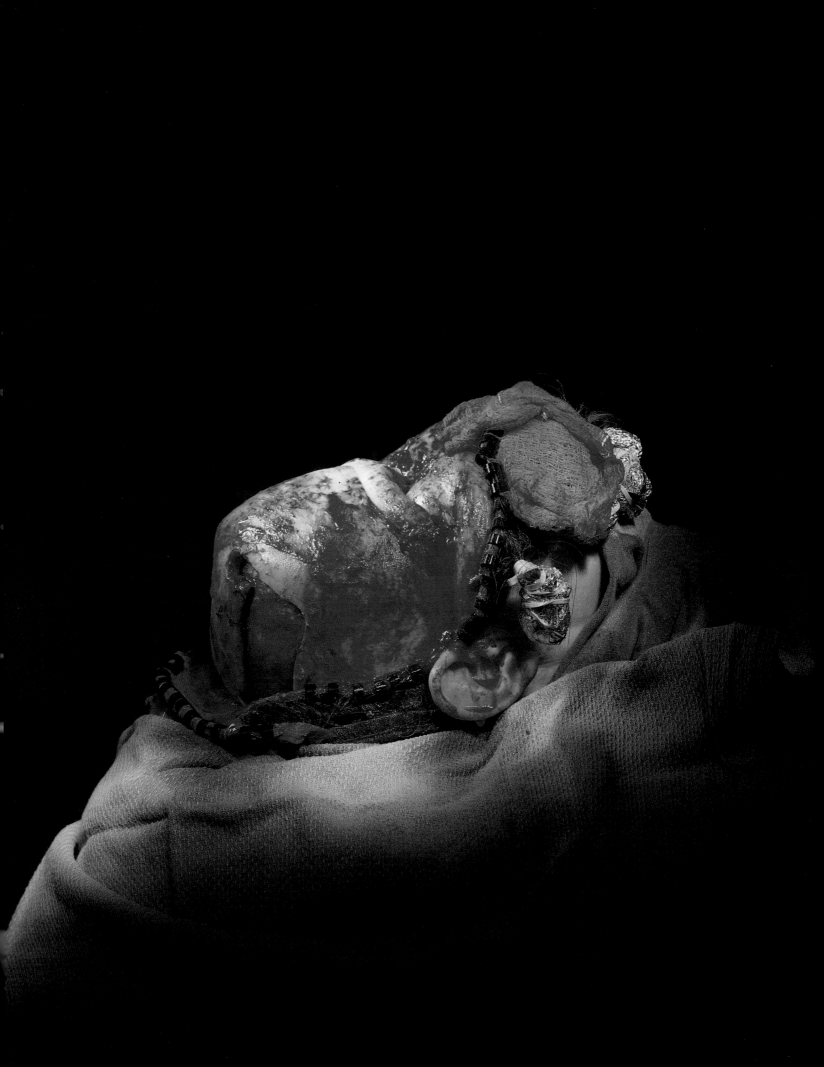

HEAD

The horse reared up and fell over backward. I hit dirt and heard the branch of a tree break. But it was the sound of human bone. When I opened my eyes, I saw sky and looked at the leaves of the trees hanging high overhead. I thought I heard the sound of helicopter blades, but it was the horse. He'd rolled over, gotten up on his feet, and taken off at a gallop. Then there was silence. I remained still, frozen, afraid to move my neck for fear of what I might discover. Thoughts began to race in my head: how you could wake up in the morning and truly not know what was going to happen that day; how a seemingly random event could very possibly rewrite your life; how something so insignificant as brushing your teeth just one minute longer could have altered the sequence of events that led to this very moment, this very thought: that if instead of walking out the front door I'd chosen the back door or taken a cold shower instead of a hot one, it might have altered the timing, the vector, the XYZ coordinate, the flight pattern of the tick or fly or God knows what that had spooked the horse, made him reach for the sky, lose balance, and fall back precisely and irrevocably upon my right arm, right wrist, and right leg.

21

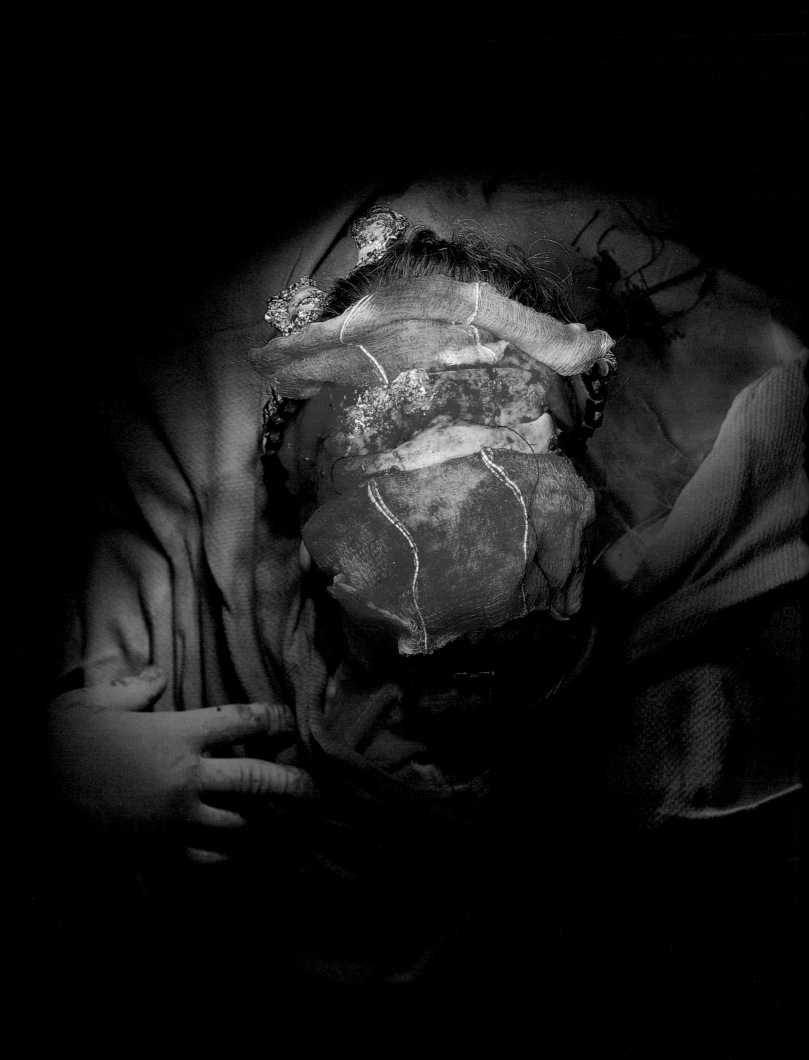

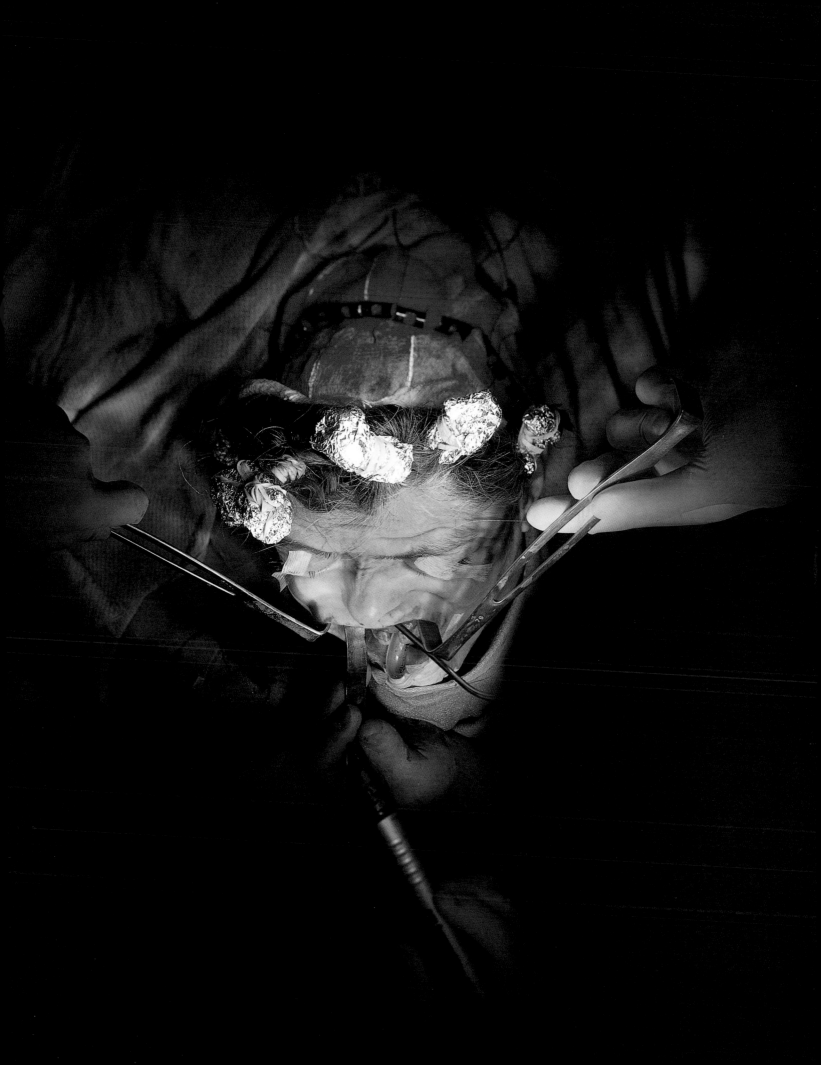

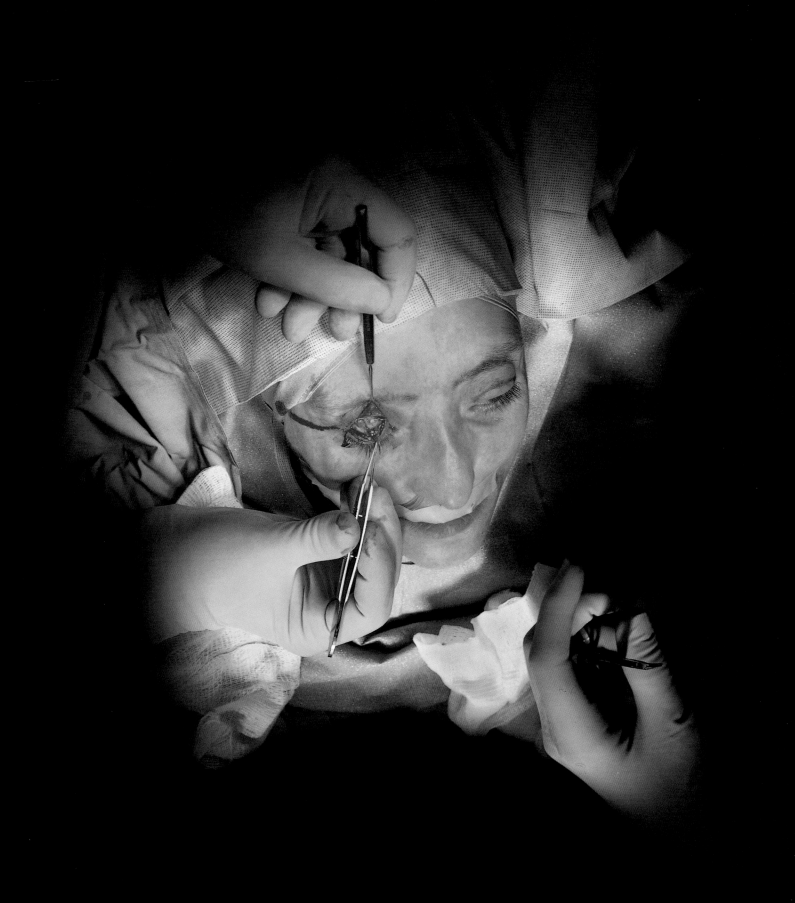

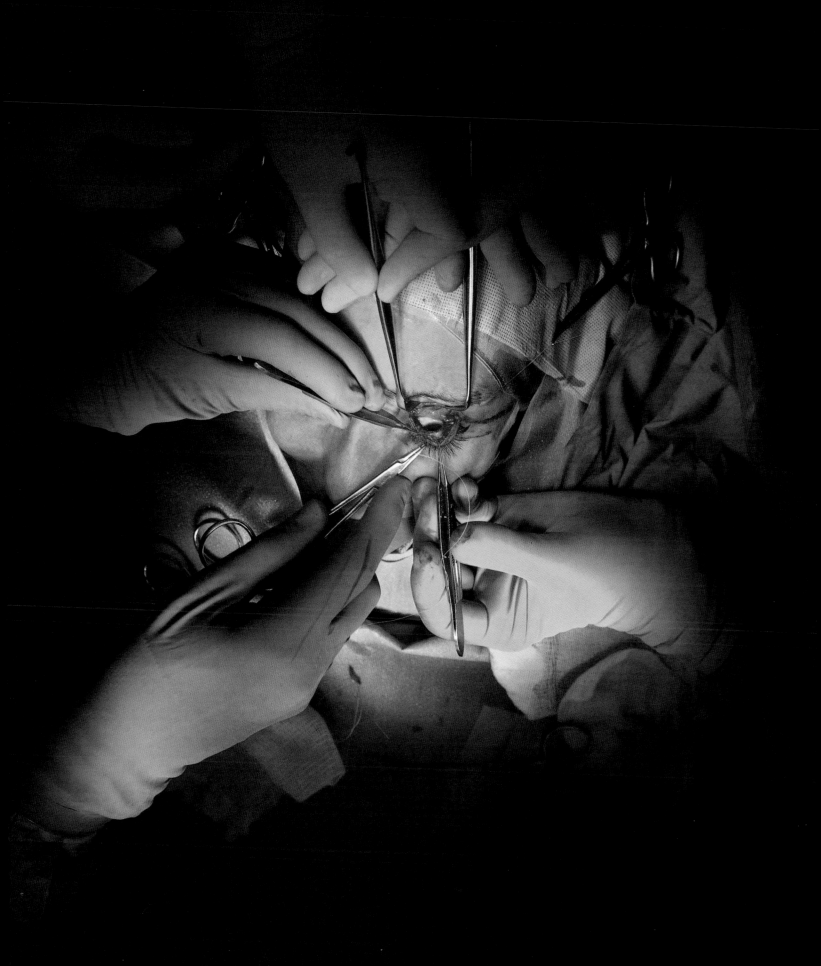

I had been sent out West by a travel magazine to photograph a dude-ranch cattle drive. Early on the day of the accident we found a dead steer rotting in the sun. We tied a rope around its head and hitched it to the tailgate of a little Toyota pickup. We gunned the engine and yelped and hollered, while watching through the rearview mirror as the rough Wyoming earth ripped bone and gristle from the carcass. We were real cowboys all right. As I lay there later in the desert scrub, I pondered the moral significance of dragging the deceased animal. It was as if we had broken some law. Out West you pay in blood, an eye for an eye, a tooth for a tooth, a bone for a bone.

Around midnight I was staring up into the faces of two surgeons, an anesthesiologist, and a nurse. I remember counting backward, ninety-nine, ninety-eight, ninety-seven. Sometime later, in a deep narcotic sleep, my eyes opened. I saw the surgeon twisting my arm freely at the elbow in a direction it had never been and was never meant to go.

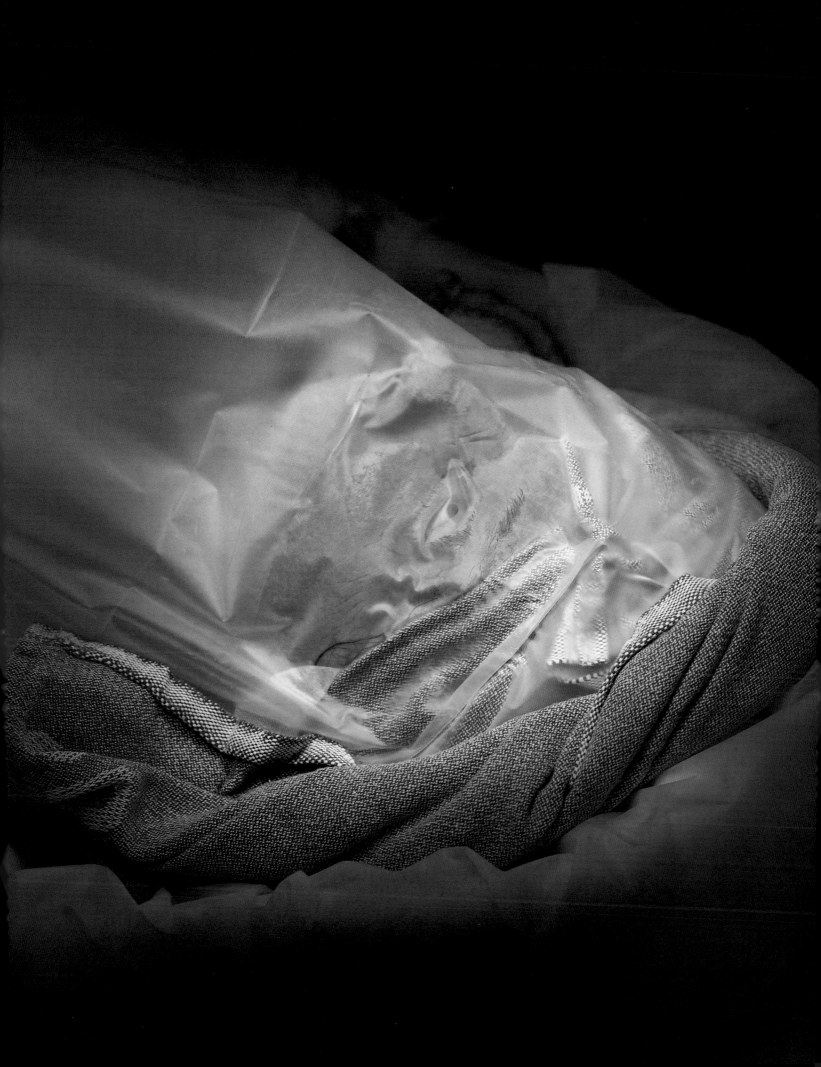

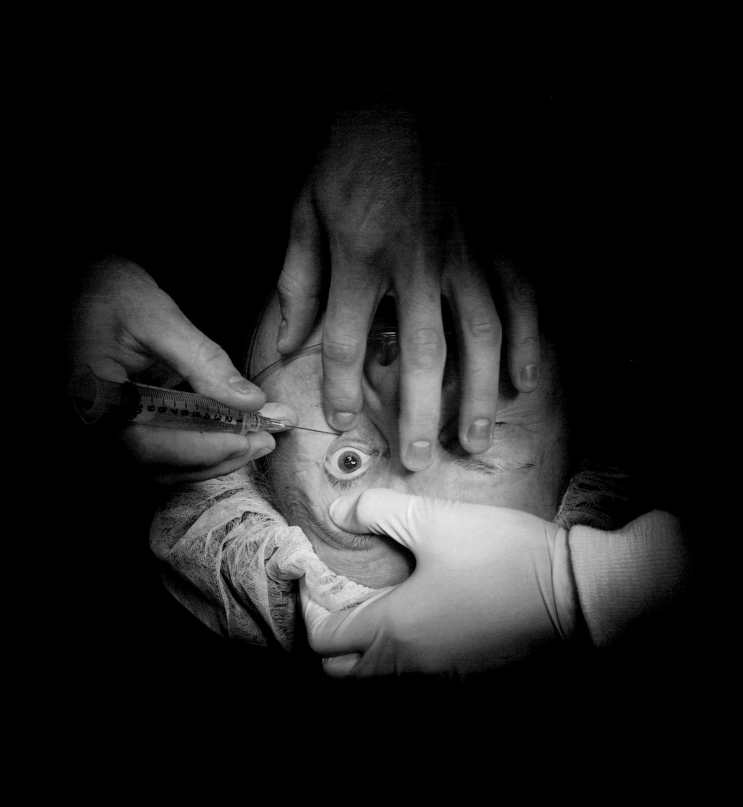

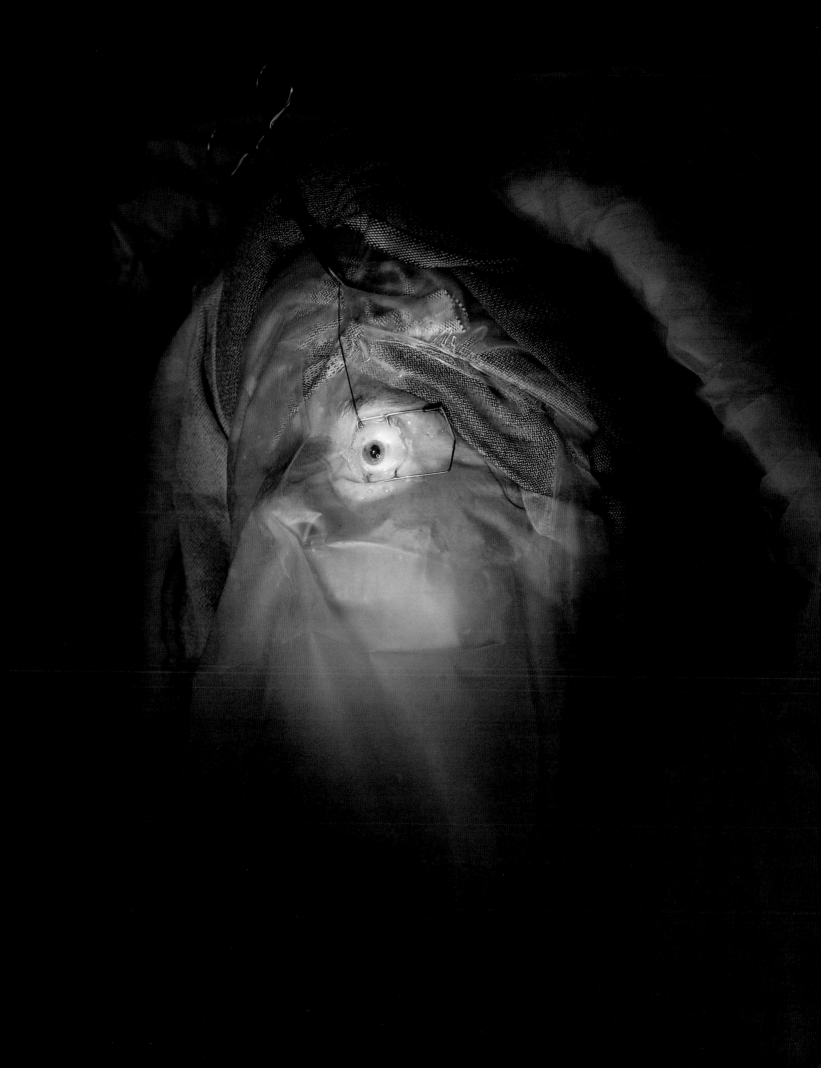

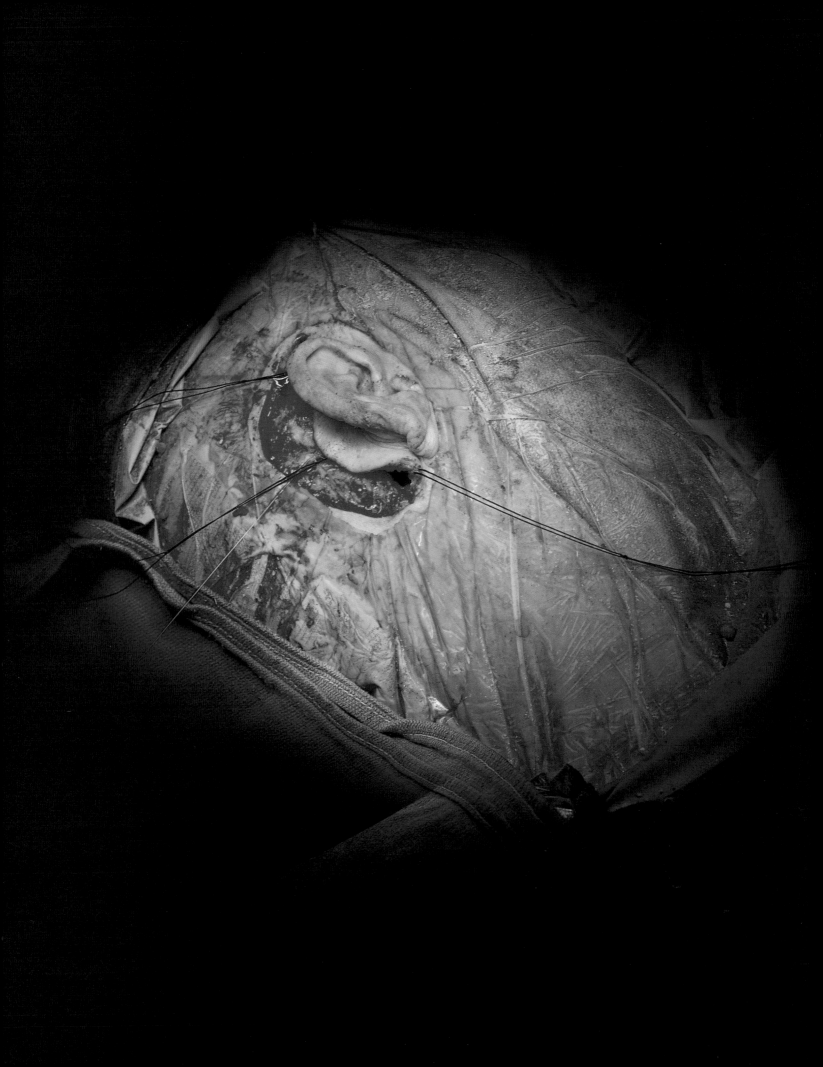

It took a few weeks before I began to walk. I used crutches at first, then limped for a while. But it would be a year before I could fully use my arm again. A photojournalist for twenty years, I lived on the road. My work, my very existence, depended on mobility. Now I couldn't even hold a camera. I had to work on a tripod. I traded in all my 35mm equipment and purchased a large-format camera, a 4 x 5 that *had* to be used with a tripod. I had always wanted to work in large format anyway. A four-by-five-inch negative could render flat images so terribly real that every pore of a person's face, every follicle of hair, even a dab of spit dribbling from the lips was revealed.

Working as a photographer, I was constantly thrust into new situations; I had learned not to plan ahead or think about what I was going to do until I arrived. It was, in fact, what I liked best about photography — the raw experiences themselves. In a given week I might crawl through tunnels with "aliens" as they entered the United States, have an hour alone in a cell with an eighteen-year-old mass murderer, and visit the White House to photograph the vice president. I have spent time with girl gangs in East L.A., schizophrenic twins in Maine, and in brothels in Bangkok where twelve-year-olds had been sold off by their parents.

Six months after my accident, in the winter of 1989, I was given an assignment by a business magazine to photograph a female neurosurgeon. The art director wanted both formal portraits and documentary photographs of the surgeon at work. The night before I was to see my first operation, a friend asked me if I was worried I would get sick. Far from getting sick, I felt what I can best describe as awe. Photographing my first surgery was so foreign to any of my previous experiences that I couldn't place it. I couldn't compare it to anything. It is one thing to know there is a spinal cord in the hollow of your back; to *see* one for real is altogether different.

The fifty-five-year-old man had suffered a sudden onset of paralysis. A CT scan (a computerized x-ray that shows intimate detail) revealed that his spinal column had narrowed. Similarly to the way plaque can build up in arteries and veins, the ligaments and bones of his back had calcified and were placing undue pressure on the spinal cord. A decision was made to remove the back side of five vertebrae. In preparation, the surgeon screwed a vise into the man's skull. She pulled his head upward and attached it to a Mayfield, a surgical brace that would hold the patient vertical, hanging from his head, stretching out the vertebrae, allowing ample room for her to work.

The man's eyes were taped shut, and to detect any evidence of air entering the veins from the surgical site and traveling to the heart, a microphone was fastened to

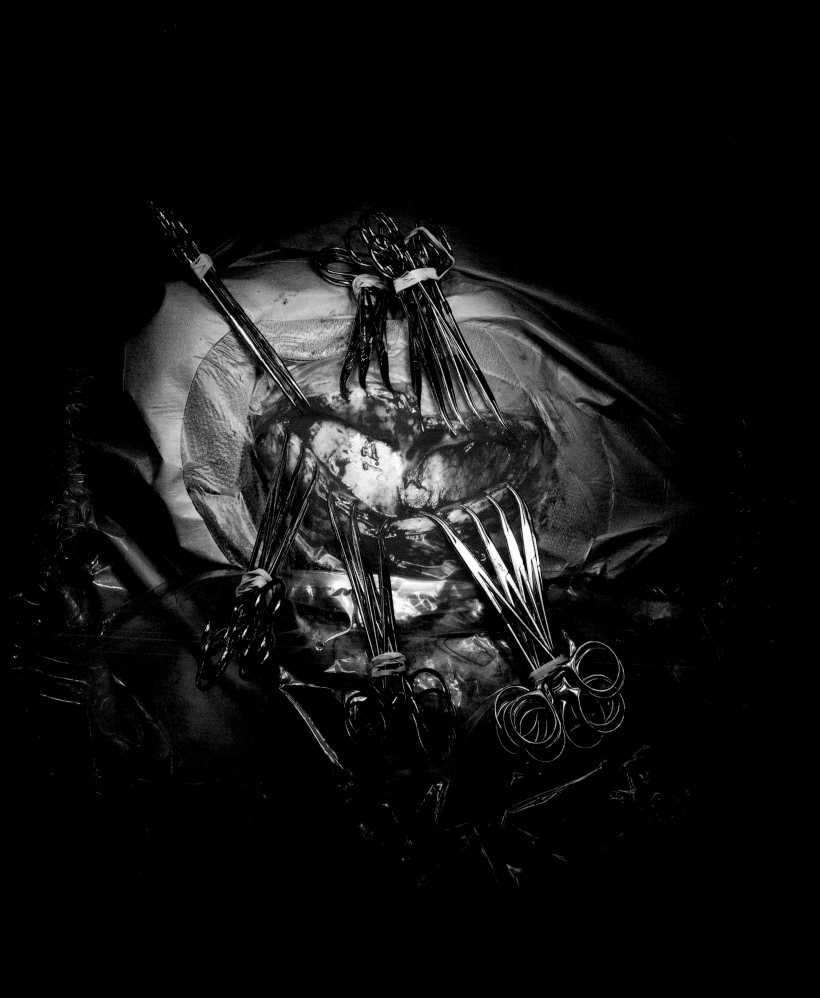

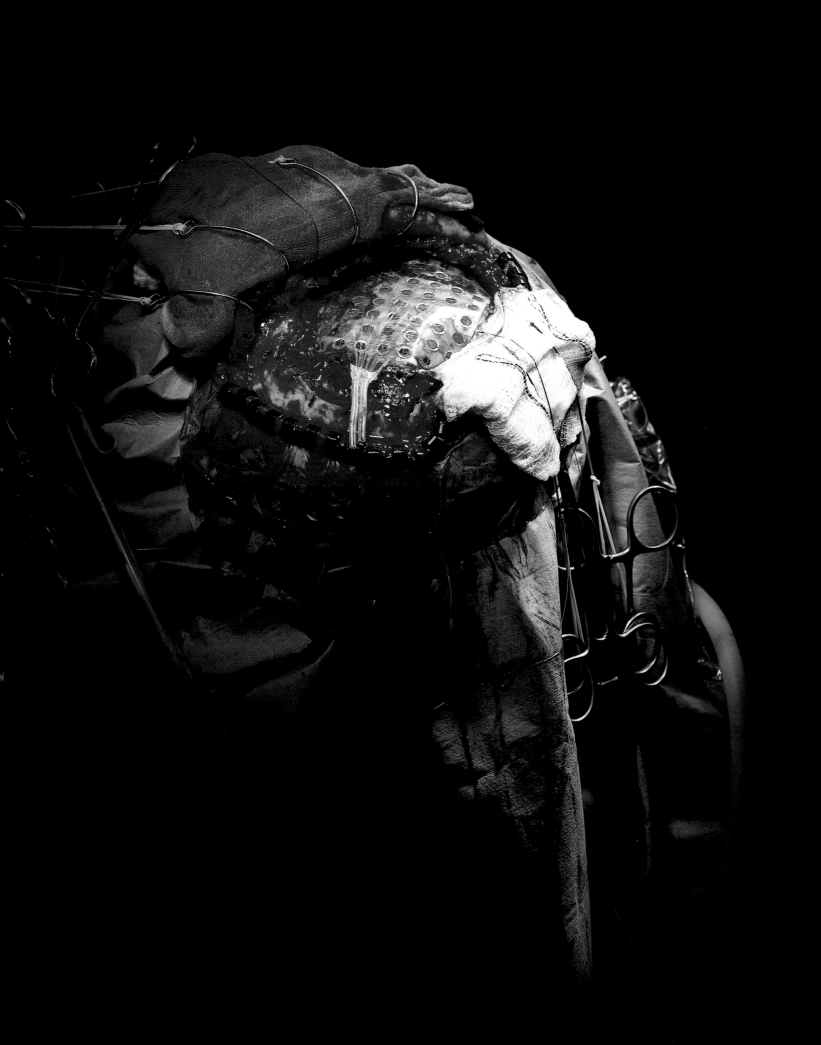

his chest. An amplifier was turned on, and the sound of his heart beating was broad-cast over a loudspeaker into the room. The sterile chamber glowed as if everything in it had a luminescence of its own. A bank of fluorescent lamps filled the ceiling from end to end, and three domed reflectors, the surgical lamps, hung over the patient. To the eye, the two sources of light blended and merged, but when properly exposed on film the surgical lamps overpowered the fluorescents; the background fell to black and created theatrical lighting on the open wound.

Draped in royal blue, awash in iodine, the patient's skin appeared golden. It rip-pled in waves like the sand in a Japanese rock garden — the effect of an adhesive sheet used to cover the surgical field to keep the incision safe from skin flakes, hair, or *veg-etation* — the mites and microbes that attach at birth and live in the skin.

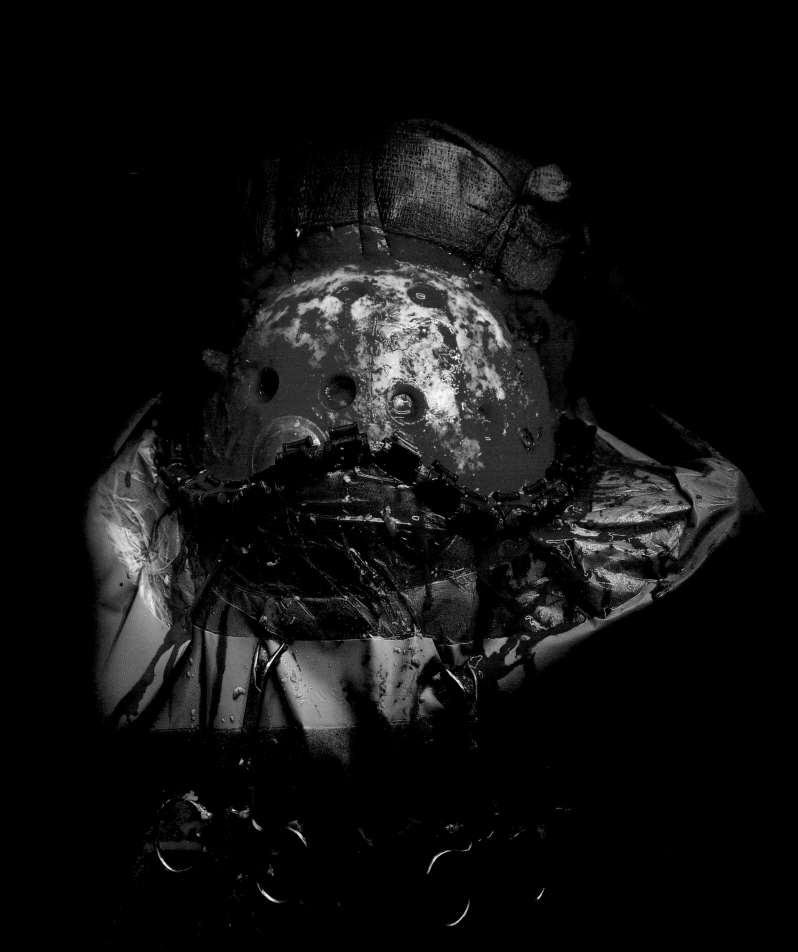

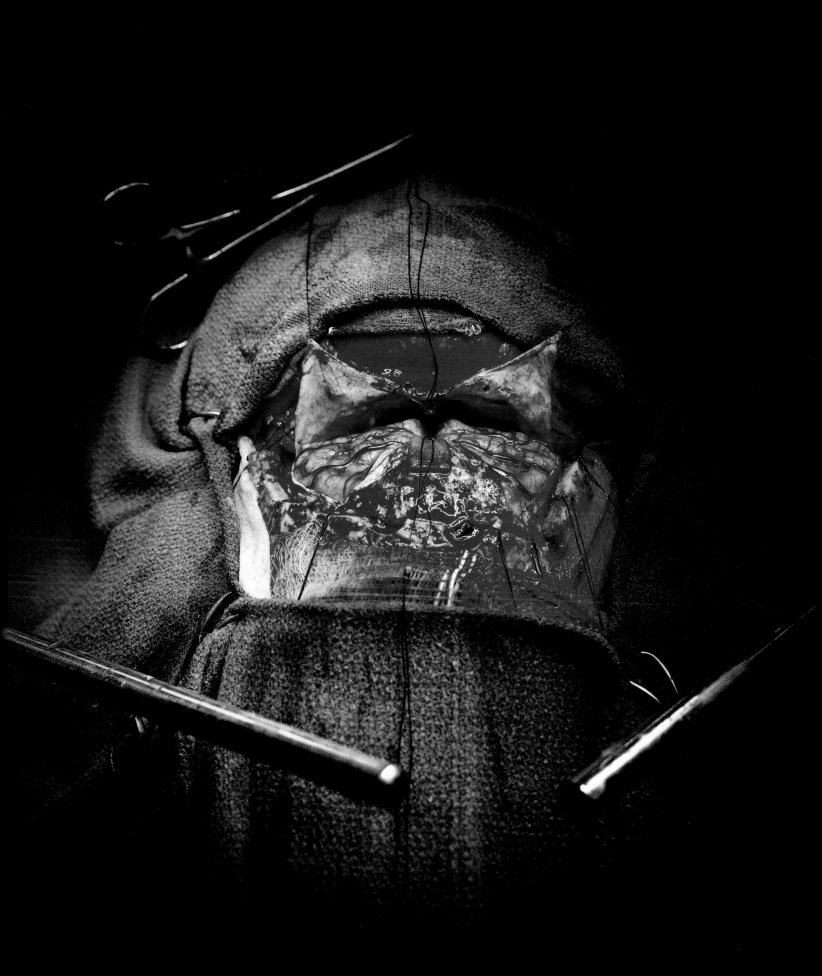

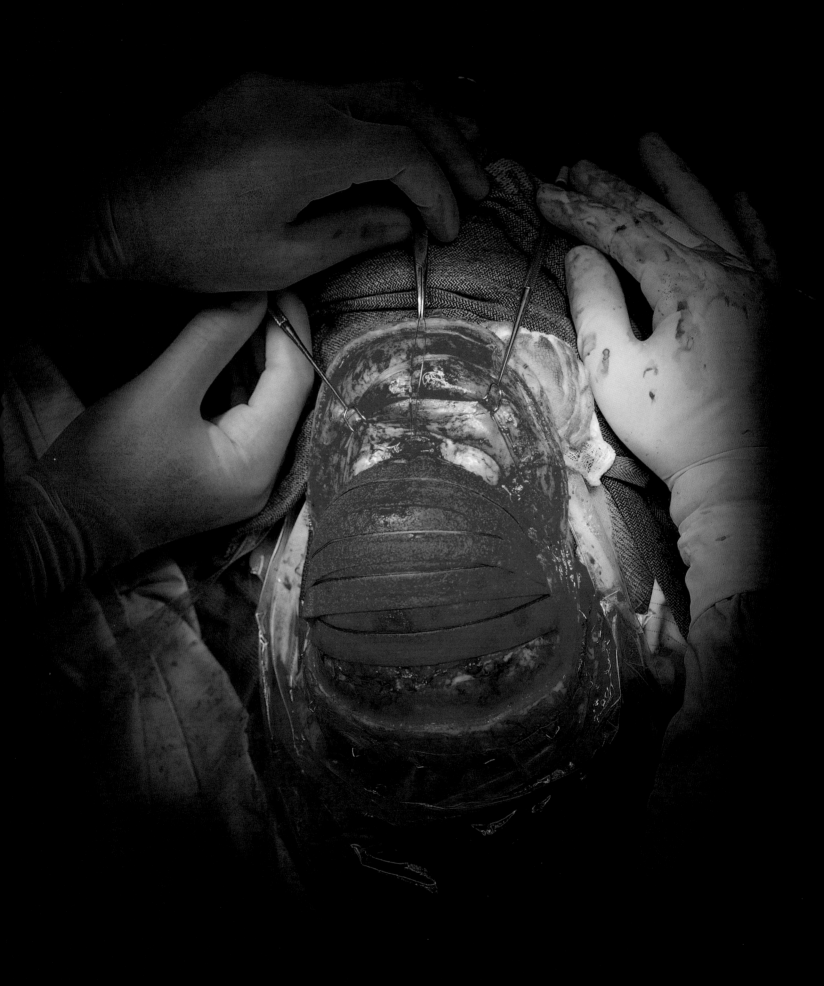

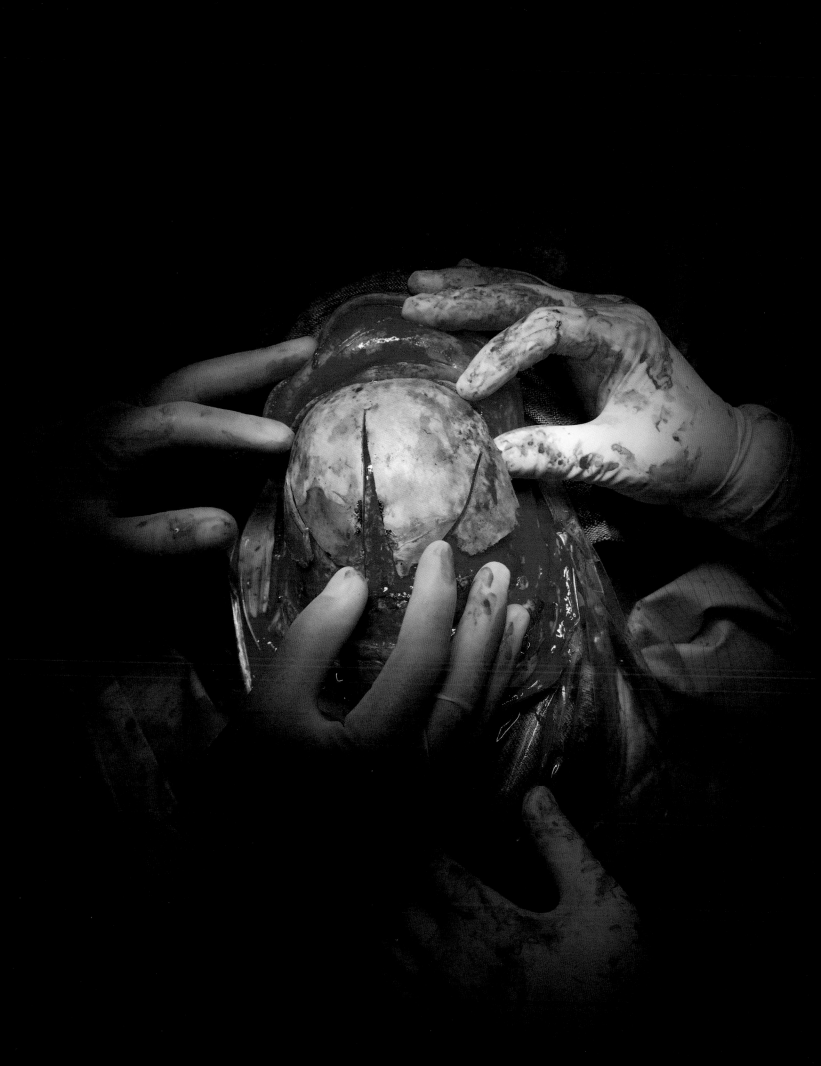

Deftly, the surgeon cut, cauterized, and chiseled. Yet the beads of sweat that one might expect on the forehead of the surgeon formed on the brow of the anesthesiologist instead. The pain of sculpted bone and seared flesh withheld, the trapezius and splenius were pierced, pulled back, pried open in the grip of stainless-steel teeth; the ivory, the calcified vertebrae, was chiseled off and sent to pathology. The heartbeat slowed but never stilled. The cardinal glow of oxygenated blood reminded me that there was a man in there. A thick, milky-white strand covering the nerve tissue that stretches from brain stem to tailbone, splitting off into minute and multitudinous nerves, producing the sensations of heat, cold, pleasure, pain: the dura of the spinal cord lay revealed. I saw the painting above my grandmother's bed. The one I saw as a child waking up from my nap. The one of Jesus. His heart bleeding, wrapped in thorns, engulfed in flames.

I realized I was in the presence of the most intimate, most vulnerable, most inviolate thing I had ever seen. The spinal cord had never seen light, wasn't meant to see light, and at this moment was bathed in light. My first impulse, I must confess, was to spit. To defile it in some way. Bring it down to my level. I didn't, of course, but I felt I was in the presence of something so precious, so amazing, so powerful, so pure, I couldn't bear the intensity.

"What is it?" I asked. "What's it made of?"

"It's like a sausage," the surgeon said, "with toothpaste inside."

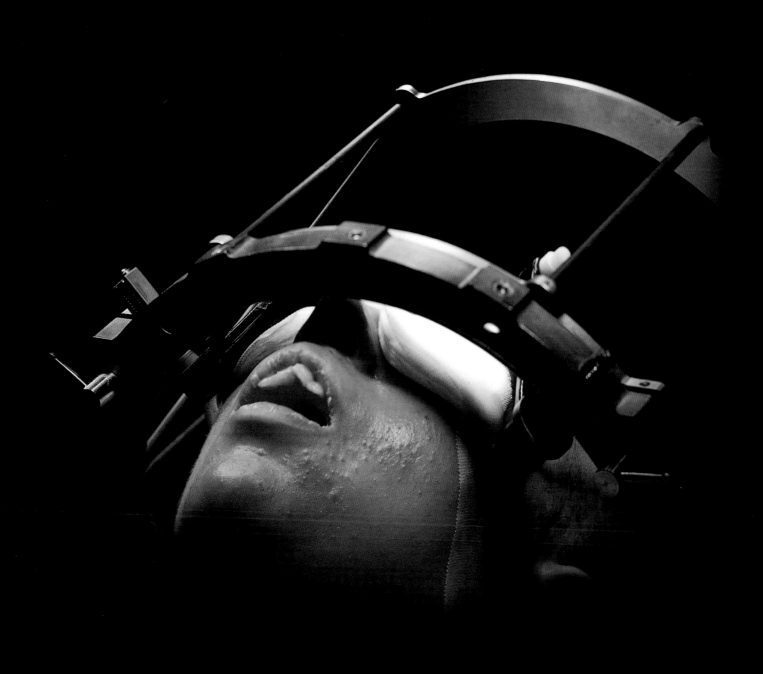

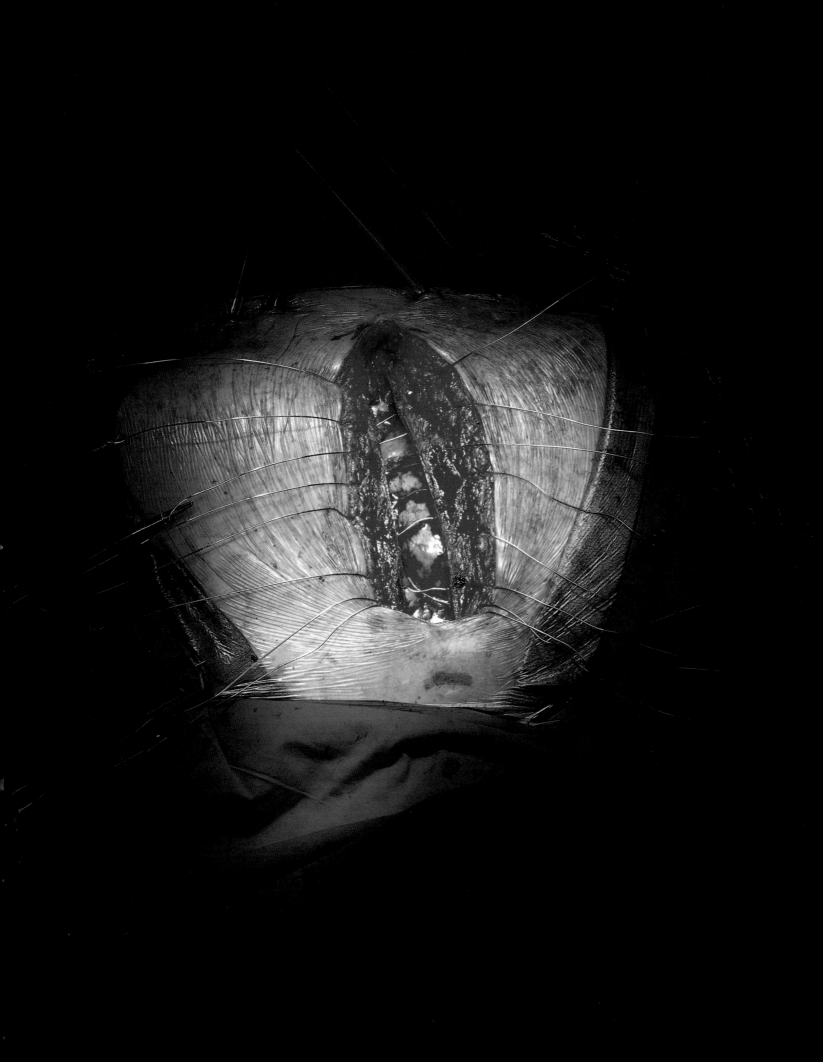

TRUNK

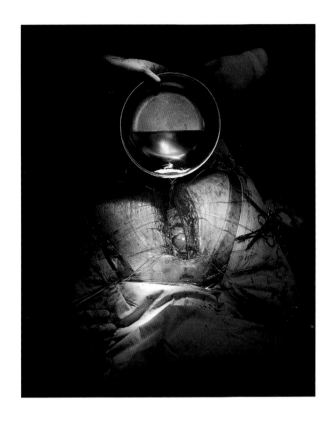

I sent a Polaroid of the spinal cord to my sister, who works as a still-life photographer. She called me and suggested I do a book. I couldn't imagine doing such a thing, but I thought it an excellent ruse to get me back into the OR. As a journalist, I had learned to talk my way into and out of things; I began to talk doctors, hospitals, and magazines into letting me back into the operating room on the pretense of doing a book I had no intention of doing. I had to go back. I had to be there. Ten operations later, I began to work on the book in earnest.

42: Sewing up the sternum with wire after lung resection
43: Irrigating wound before closing 45: Heart procured for transplant
46: Heart assist device known as LVAD 47: Installing tubing into left ventricle for LVAD

Few among us are given the opportunity to view a beating heart, a tumor, or peristalsis (the progressive wavelike movement of the intestines that occurs involuntarily to digest food). I stood astonished witnessing birth (I photographed three — two cesarean and one vaginal). Seeing cataract surgery for the first time, I marveled at the surgeon's incision into the pupil, which was not the black opaque mass that I had thought it was, but a hole, a window to the inner cavern of the eye. I was amazed to discover that there is a certain amount of fat in our bodies that is absolutely essential — that fat surrounding the heart is needed as lubrication to keep the vital organ from sticking to the inner walls of the chest. Seeing Siamese twins for the first time, I was surprised to find out that they were not freaks, but children, adorable and precious just the way they were. In fact, I came to think that they might have lost something once they were cut apart, made independent and detached.

Some operations were not what I had hoped them to be. I found the heart especially difficult to photograph — it won't stop moving. The opportunity to shoot a prostate being removed with only the application of an epidural anesthetic — the patient conscious and talking during the procedure — was surreal, but the pictures proved unimaginative and dull. Still other operations, despite the horror of the diagnosis or

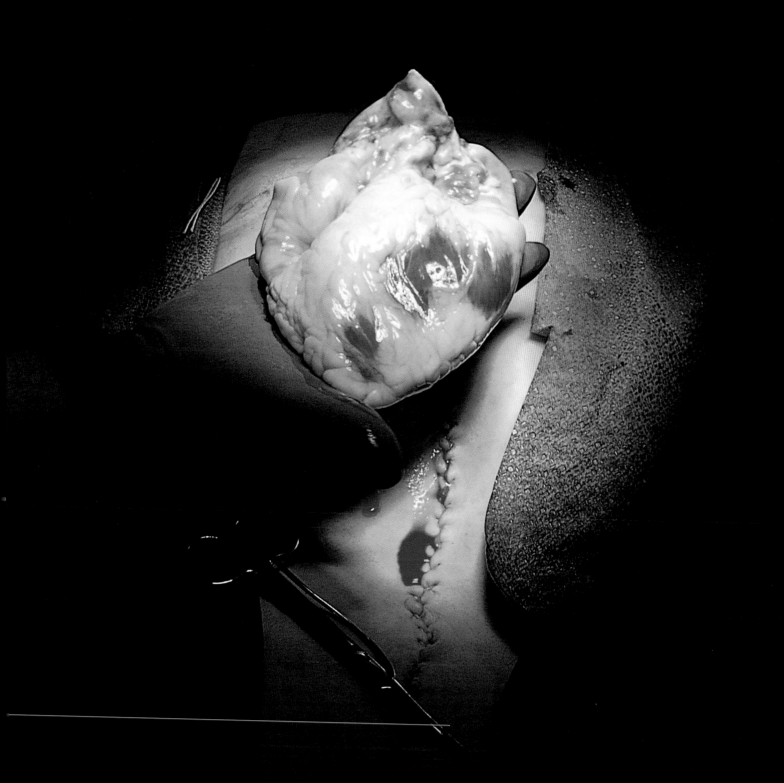

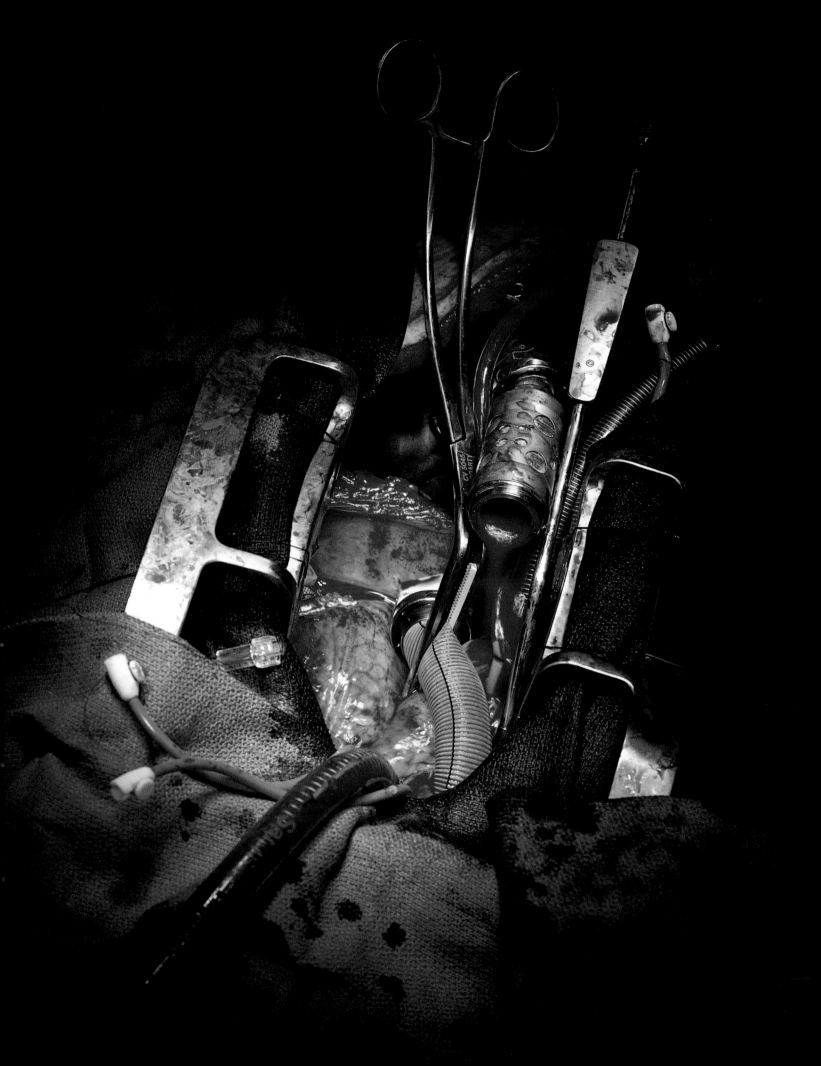

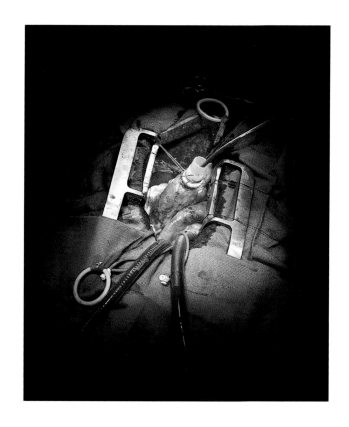

the insult to the body, were uniquely, if not mythically, beautiful — a penile implant

with sutures that recalled the ropes the dwarfs of Lilliput used to tie Gulliver down;

the hip replacement that reminded me of a Civil War battlefield, the battle over, the

gauze used to soak up blood looking like a calla lily sprouting in the field.

These images function like a Rorschach test. They may reveal more about
the viewer than they do about surgery or the body. One day I showed the pho-
tographs to the picture editor of a national magazine. As I explained the im-
age that resembled a bowling ball — "The openings that look like where one might
place one's fingers are actually holes drilled into the skull" — her expression seemed

to change, and over the sound of my own voice I could see her lips moving silently, urgently, mouthing words I could neither read nor understand.

"Instead of using a hammer and chisel," I continued, "to crack open the skull, the surgeon uses a special drill that works on pressure. Once it gets through the bone, it stops. Or is supposed to," I said, as the picture editor began to wave not one, but both hands, telling me to stop.

Suddenly, a woman at a nearby desk got up and ran from the room. "Her father just died of a brain tumor," the picture editor said.

"You showed me these pictures before," she told me now, reminding me that two years earlier I had shown her some of my first surgical photographs. At the same time I had also shown her a little book I had compiled, a handmade volume filled with portraits of Mexicans I had taken on the border. "That night, I had a nightmare," she said. "I was looking at your precious little paper book of the Mexicans; but the images weren't the photographs of Mexicans, it was a surgical procedure — not the photograph of a procedure, but the operation itself. The spinal cord. The real thing. Page after page after page."

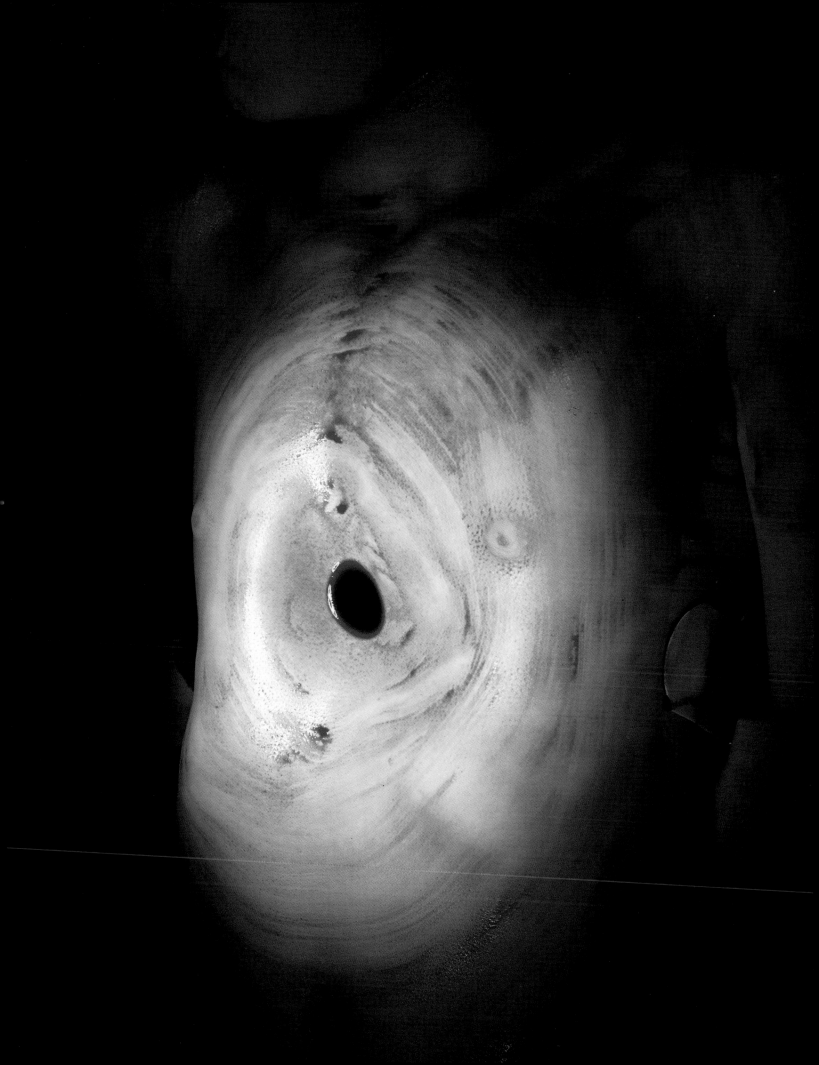

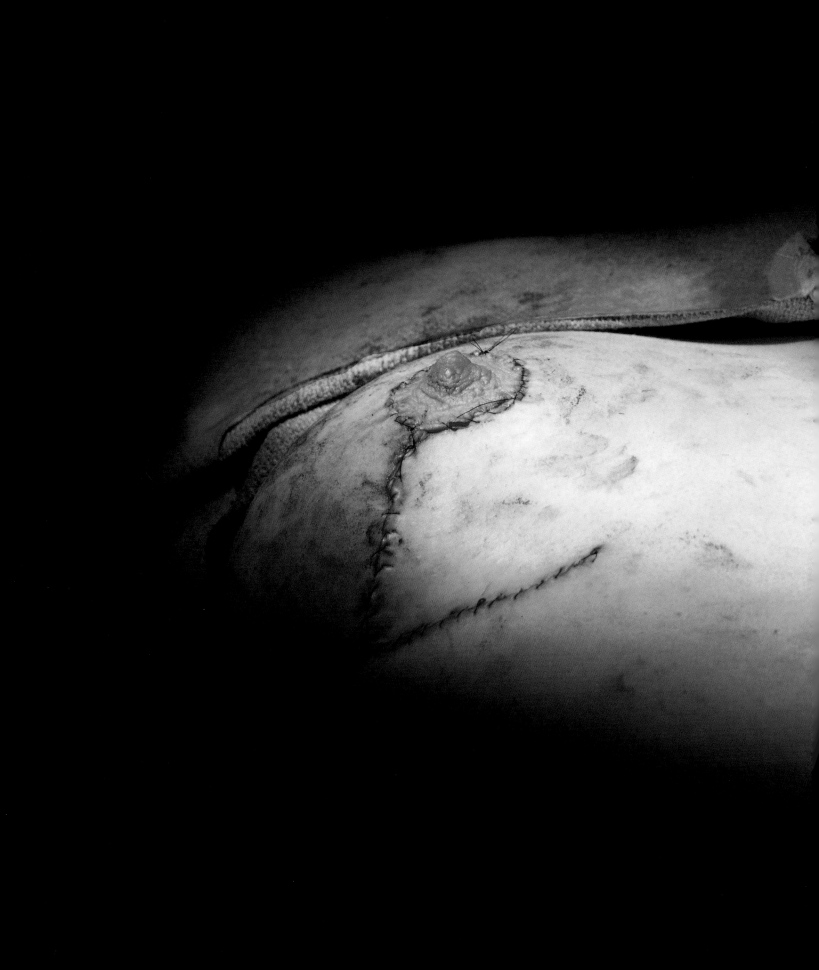

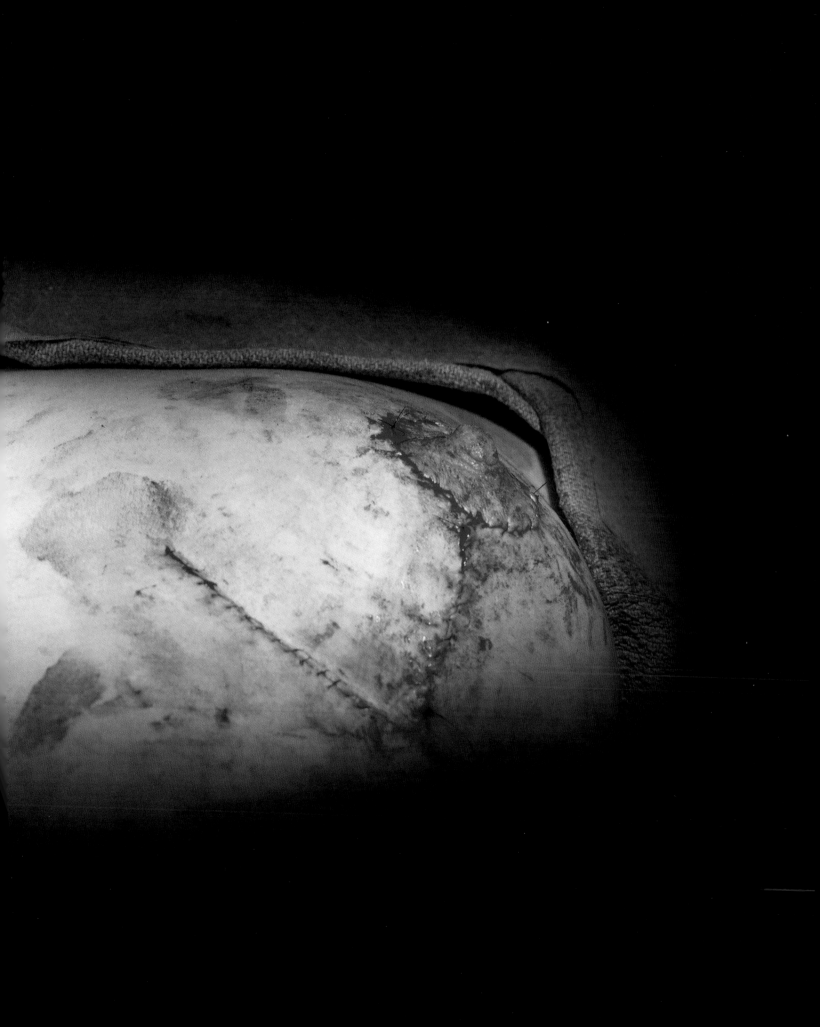

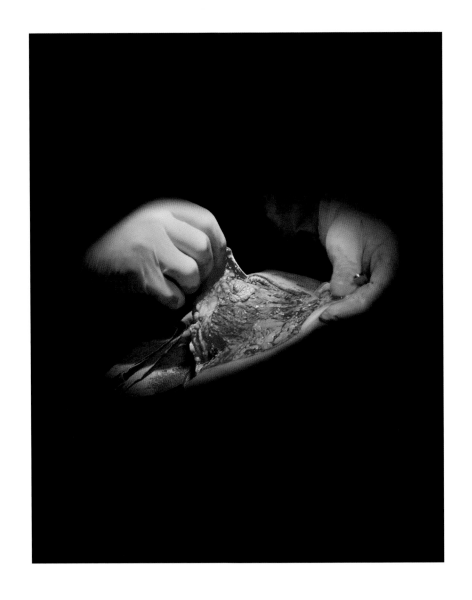

I was assigned to photograph a breast surgeon at work. His first case was a forty-year-old woman who only five weeks earlier had had cosmetic implants tucked into her breasts. One week after the procedure, her preoperative mammogram was reexamined. On second viewing, a tumor was detected growing out of control in her left breast. As she lay on the operating room table, I thought about how she might

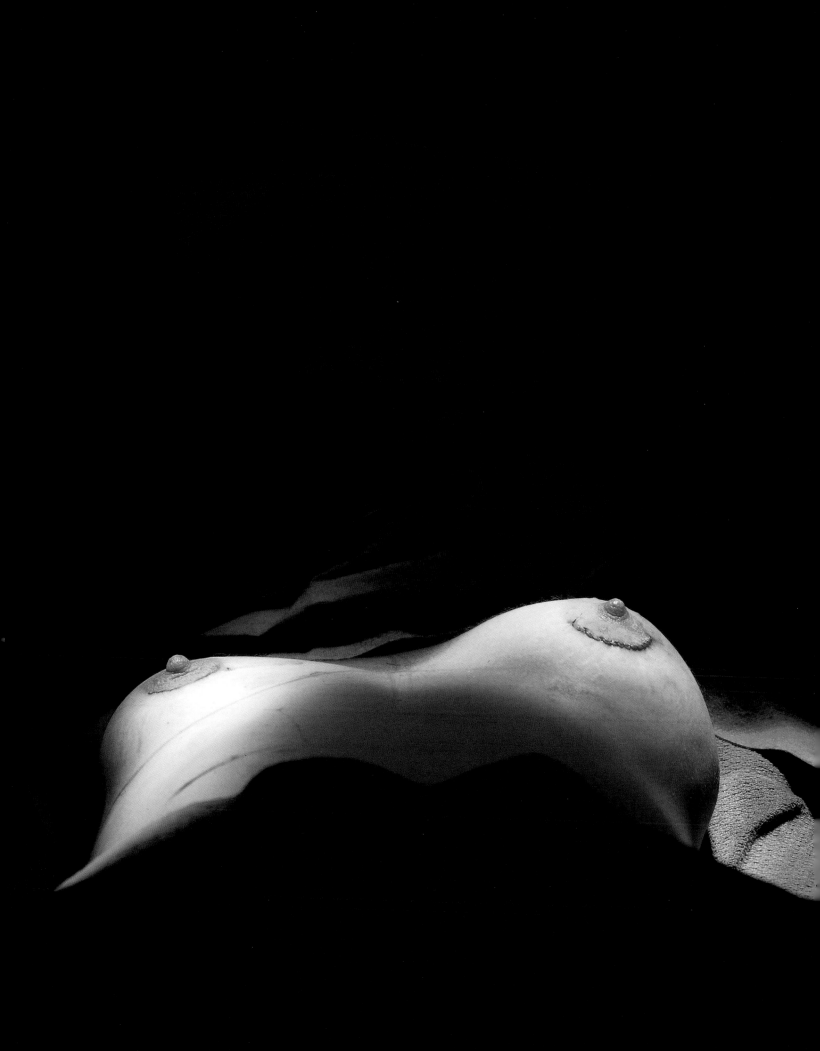

have spent the last four weeks. What does one do when told of the need for immediate and major surgery? What kind of journey does one make?

I asked the surgeon about the causes of breast cancer. "We really don't know," he said. "It could be the food, the water supply, a host of other factors, but nothing we can say for sure. The only thing that seems to give any indication is a family history of the disease. Vertical transmission, parent to daughter.

"My next case," he added, "is a thirty-five-year-old woman who came to me five years ago without any symptoms, pleading to have her breasts removed. Her mother had died of breast cancer two years before and just that week her sister had died. She begged me to operate. I told her no.

"Had I done a prophylactic procedure five years ago, she might never have developed cancer, but she did. Today, I have to perform radical mastectomies on both of her breasts. I have to remove the muscles as well."

As I thought about how brave these young women had been, the surgeon finished the excision, removed a triangular section of flesh — the areola and nipple — and beneath it, the compound glands of the female breast that can secrete milk, and set it in a tray. He asked the nurse to call pathology and began to close the wound. It was as if there had been no surgery at all. With the lethal tissue removed, the patient's silicone implant was left intact; the form and shape of a breast remained. She was just missing one thing.

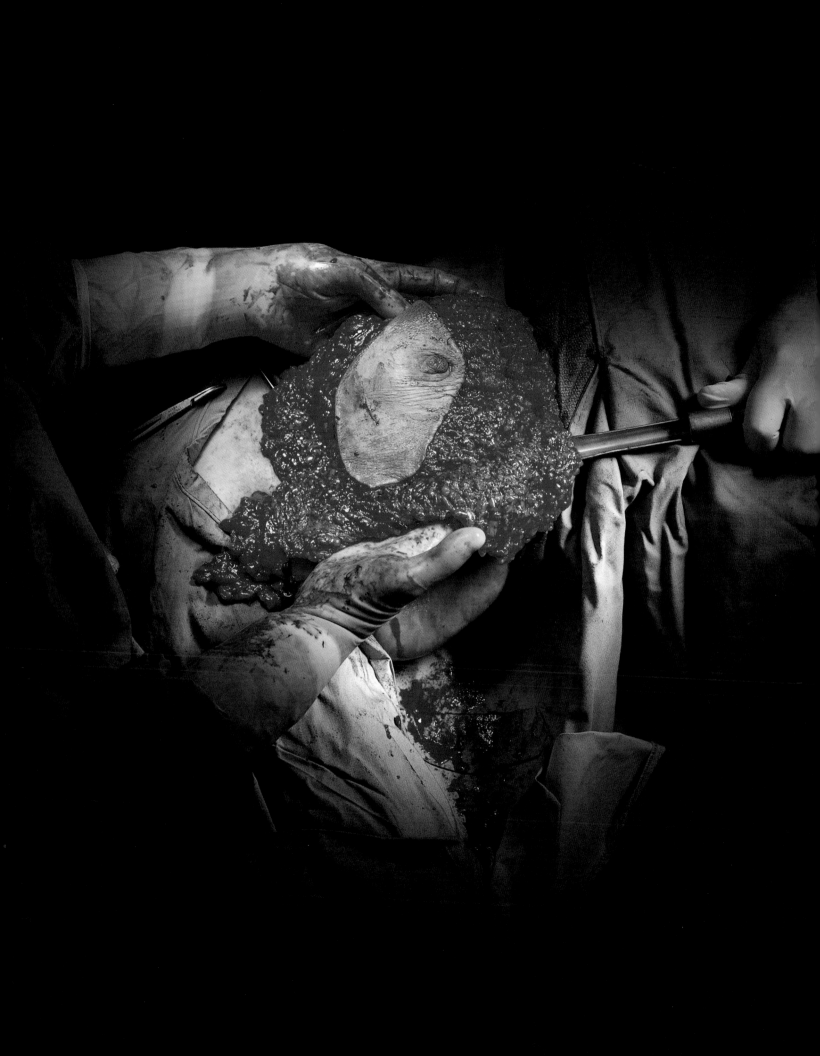

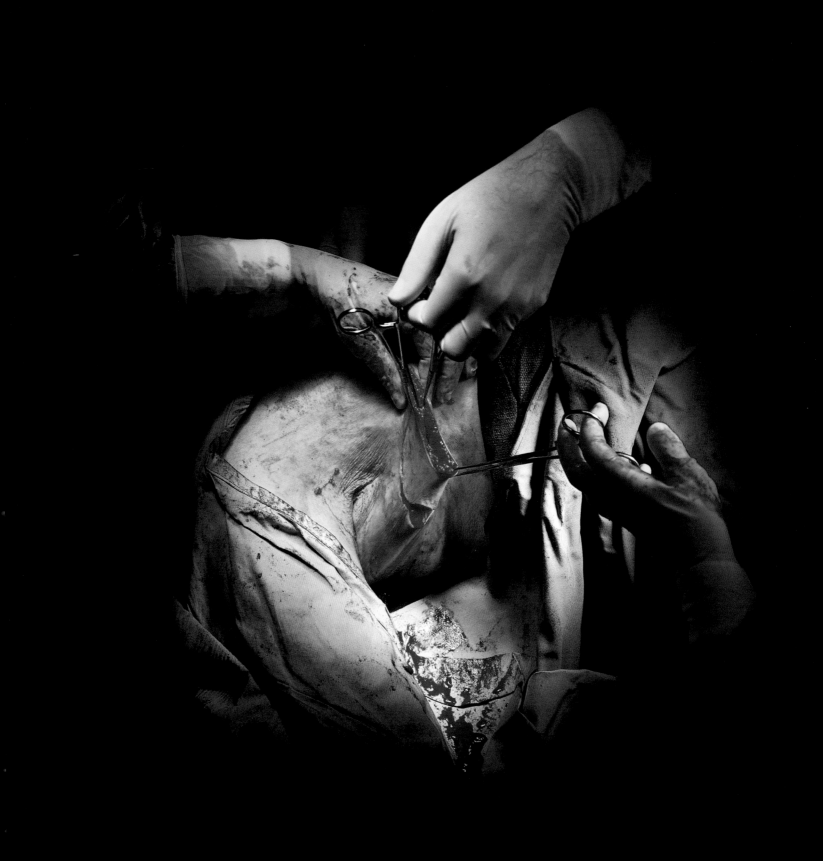

"Years ago," the doctor said, "we used to take a piece of earlobe or a section of the labia and sew it to the breast. The labia has the same quality of tissue as the nipple. But there were too many complications, so we don't do that anymore. She'll have cosmetic surgery instead. In a few weeks, where the scar is, we'll take the skin, rotate it to give projection, and then tattoo an areola. We put nipples on every day."

A young medical student in scrubs entered the room. "Pathology here," he said.

A nurse picked up the tray containing the excised breast and passed it to the waiting messenger. For a brief moment the nipple and areola lay illuminated under the operating room lamp. I thought about the tissue's history, its very life. Had it been the object of desire? Had a child suckled it, garnering sustenance and comfort? Was the woman's motherhood in that tray? I asked. Was her sensual self embodied in the four-by-three-inch pyramid of skin, gland, ducts, and fat? No. It was still inside her. It was part of her, no matter how much was cut and taken away. I thought once again of the woman's journey, the pilgrimage she would undertake, the leap of faith she would have to make for herself.

That night I had dinner with two women friends I hadn't seen in a long time. As I recounted the events of the day, they were livid. "You male chauvinist pig," one said. "You

Neanderthal from the sixties," the other cried. "The only way you can think of a woman is as a sex object or a mother. What if it were a penis that was being sliced in half!"

Many times while working on this project, I thought that perhaps I was mentally ill, that I might suffer from some kind of blood lust. I began to enjoy my own illnesses and was upset to find the lump behind my ear was not a cyst that required surgery but only a swollen gland. While having a tooth pulled, I asked for mirrors so I could watch. My friends found me staring at them — not looking at them, but looking in them — and became unnerved.

After one particularly long and arduous procedure, I had seen so much surgical carnage in one day that when I tried to close my eyes to sleep, I saw the dark tranquillity of arteries and veins instead — image upon image of subcutaneous tissue — melting, shifting, changing like a bloody kaleidoscope. *Gray's Anatomy* on acid.

Months later, I asked a transplant surgeon, after a long hard night, what she saw when she closed her eyes.

"Did you ever see *The Shining?*" she asked.

"Yes," I said.

"The scene where the elevator opens and a sea of blood gushes out the door?"

"I remember."

"That's what I see," she said. "Rivers and rivers of blood."

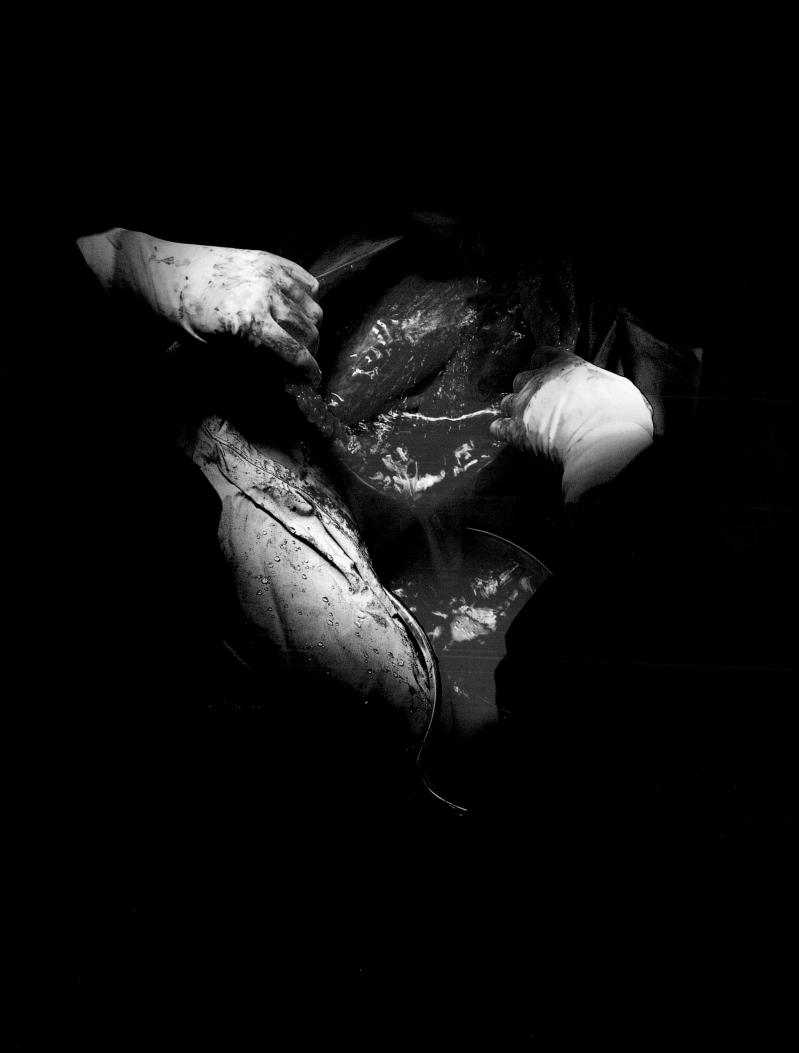

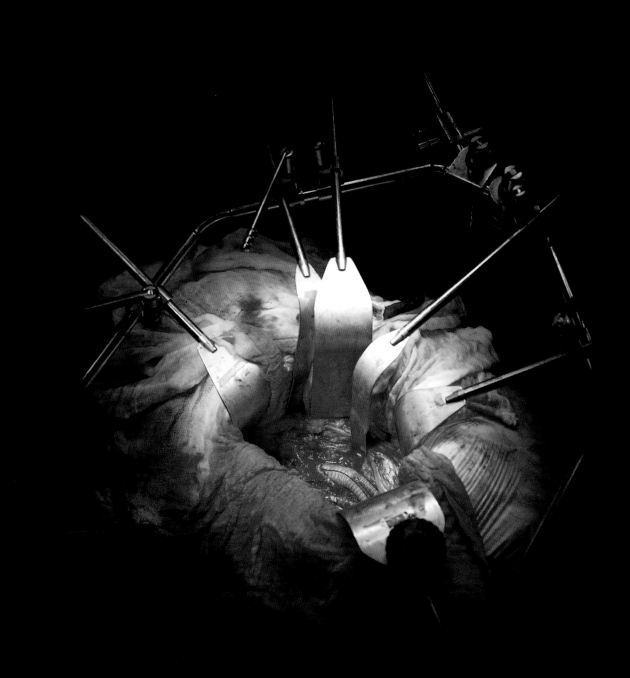

HARVEST

I read medical charts now the way I used to read novels. The following, for example, is a summary note from the medical record of a thirty-seven-year-old mother of three — a three-inch stack of paper generated during and detailing the last few hours of her life:

37 YEAR OLD WHITE FEMALE WAS SITTING IN CHURCH WHEN SHE WENT STIFF. PUT HEAD BACK AND COLLAPSED. FOUND TO BE PULSELESS AND APNEIC [not breathing]. CPR FOR 3 MINUTES. PULSE RETURNED, NO RESPIRATION. GIVEN MOUTH TO MOUTH BY HUSBAND FOR 20 MIN. EMT ARRIVED. INTUBATED [breathing tube inserted in the larynx] AND O$_2$ [oxygen] GIVEN. HR [heart rate] SHOWED S/T CHANGES [an EKG tracing — a hallmark of myocardial ischemia, or injury to the heart]. TRANSFERRED TO ER AND HAD REPEAT CARDIAC ARREST. CPR 20 MIN. DEFIB X3 [defibrillation three times — an electrical device used to apply countershocks to the heart in hope of resuming the normal rates and rhythm of the heart] @ 300 JOULES. ICP [intracranial pressure] MEASURED AND HORRIBLE [extremely elevated]. HUSBAND CLAIMS PT [patient] HAD NO PREVIOUS NEUROLOGICAL HX [history]. PT TRANSFERRED TO CT [computed tomography — an x-ray technique that produces a film representing a detailed cross section of tissue structure. Tumor masses, infractions, bone displacement, and accumulations of fluid may be detected]. POST CT, MRI [magnetic resonance imaging — analysis of electromagnetic energy and its effect on atomic nuclei — valuable in evaluating large blood vessels, soft tissue, the brain, and heart] PERFORMED TO R/O [rule out] ANEURYSM. INTRACRANIAL BLEEDING FOUND. PT TAKEN TO OR. 2 CM HOLE DRILLED TO RELIEVE PRESSURE. UNABLE TO CONTROL BLEEDING. ADMITTED TO ICU [intensive care unit]. NORMAL REFLEXES ABSENT. ALL LIMBS FLACCID W/NO SPONTANEOUS MOVEMENT. COLD CALORIC TEST UNRESPONSIVE [cold water forcefully injected into the ear]. EEG [electroencephalogram: electrical measurement of brain activity] FLAT. BRAIN DEATH CERTIFICATION REQUESTED. HUSBAND NOTIFIED. TIME OF DEATH, 2100 HOURS. CONSENTS [organ donation] REQUESTED.

60: Aortic bypass for atherosclerosis
63: Liver transplant 64: Cirrhotic liver
65: Tumor associated with liver disease

The next several pages detailed the neurological consults, blood and urine collected and analyzed, the lifesaving procedures that had been attempted, the step-by-step confirmation of what is called brain death.

When we die, most of us die a cardiopulmonary death. That is, no matter the particular cause of death — cancer, AIDS, pneumonia, murder — it is the heart and lungs that stop; then, shortly thereafter, the brain ceases to function. But in a small percentage of all deaths, it is the brain that goes first, the heart following close behind. Brain death prior to cardiac death requires trauma to the central nervous system: gunshot wound, motorcycle accident, drowning, baseball bat to the head, stroke, aneurysm (dilation of a blood vessel, usually an artery swelling up and exploding in the brain).

Organ donors must die brain death; tissue donors — eyes, skin, bone, heart valves, and saphenous veins — can have suffered cardiac death. In the final moments of life, if brain death occurs inside a hospital and ischemia (loss of blood supply to the heart) can be prevented, the organs can be kept alive by keeping the donor intubated and on a respirator. Timing is critical. A human heart is good for only four to six hours. A liver for eight to twenty-four. Kidneys can be kept viable for as long as three full days.

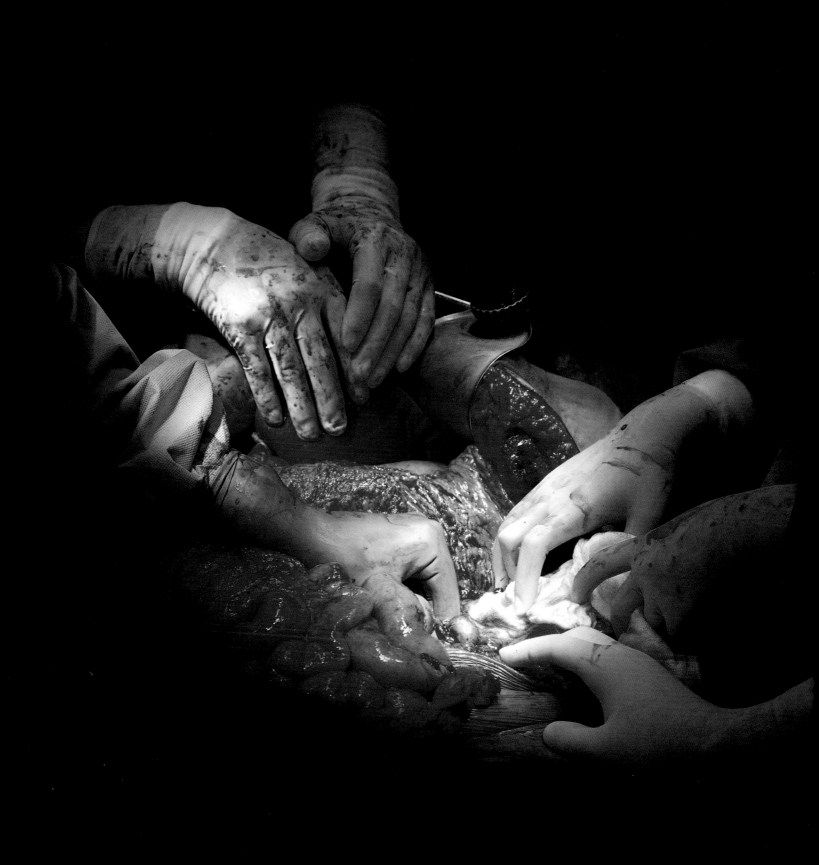

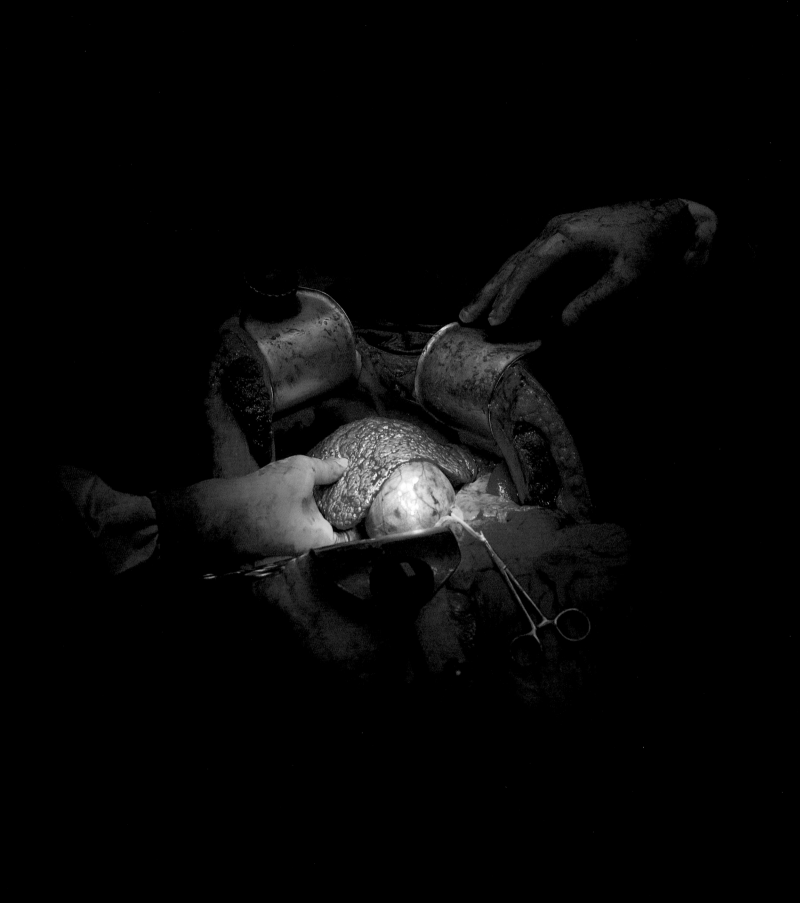

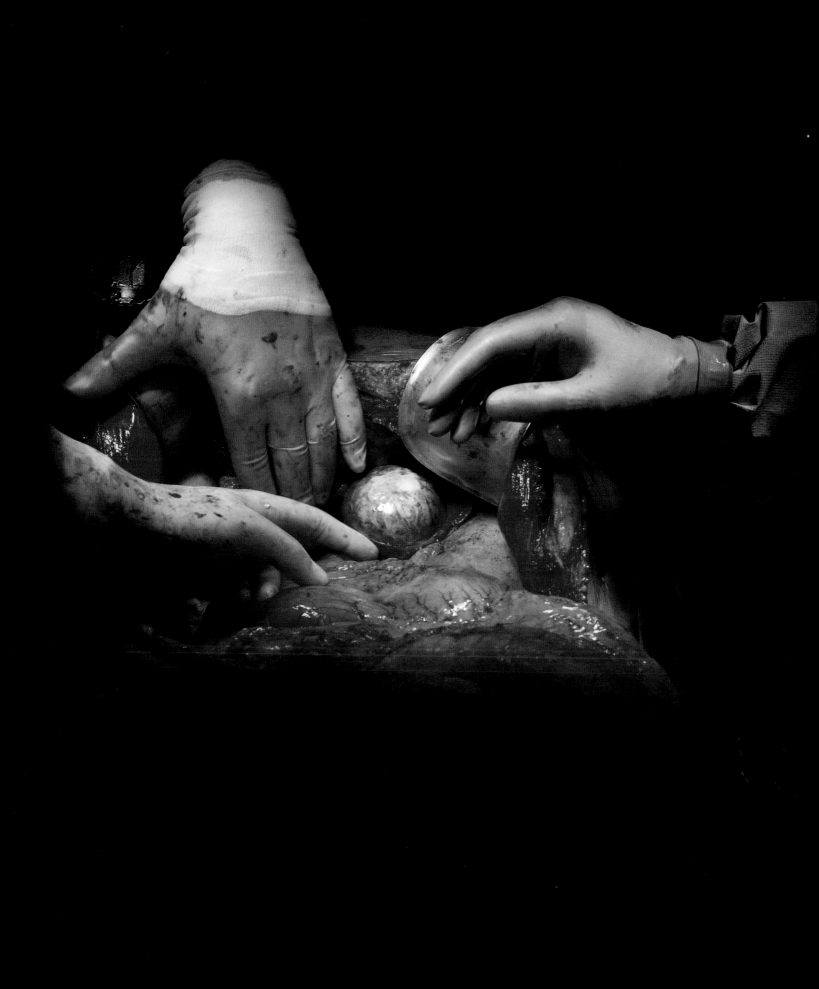

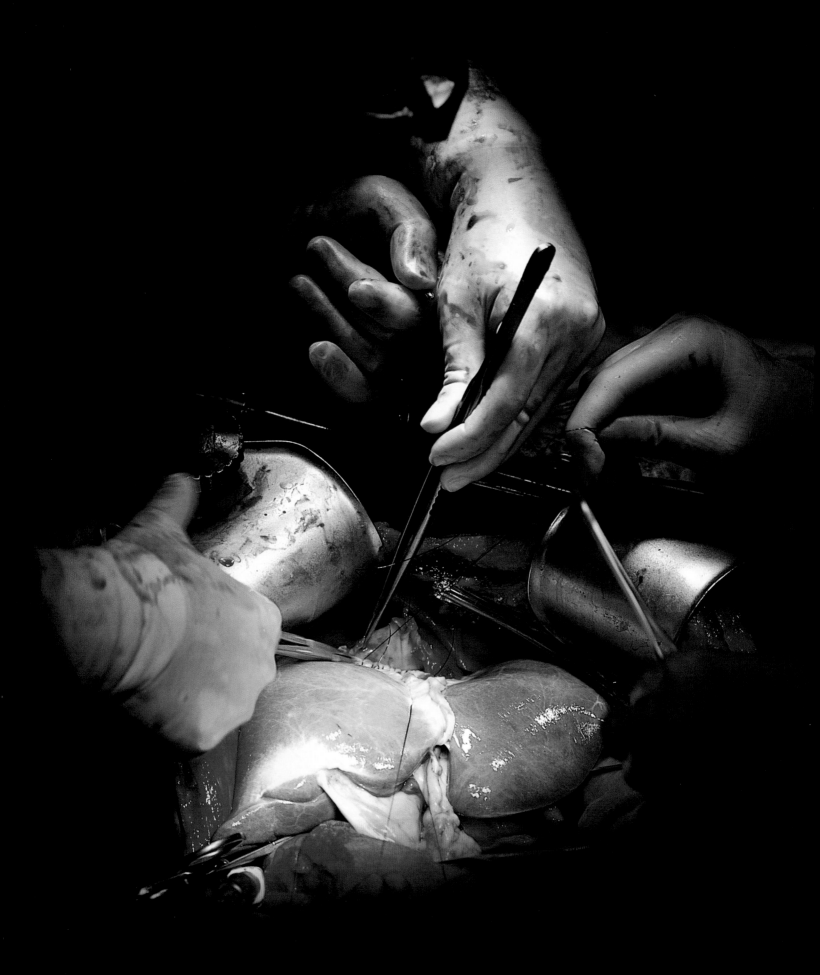

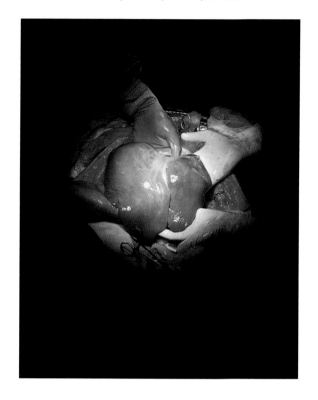

Brain death certification is serious business and cannot be easily explained. It is difficult for the family of the potential donor to comprehend that their loved one is dead when they see the person breathing on a respirator. Specifically, it is hard to explain the difference between brain death and coma. Because of the incongruities, the sensitivities, the subtleties of this distinction, some states require certification of brain death by two separate physicians.

The last document of the thirty-seven-year-old woman's medical record was a checklist of body parts, the inventory of organs to be donated for transplant or research, marked with an X, and signed at the bottom of the page by her husband, who had given his consent. I tried to imagine what kind of pain, what was the nature of

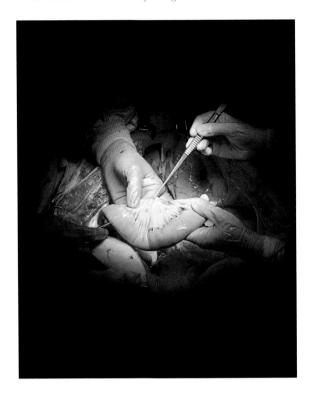

the generosity he felt as he signed his name. But nothing could have been stranger

than seeing the surgeon open up her chest, her heart still beating, her lungs taking

oxygen, yet knowing she was dead.

Teams of surgeons arrived from various hospitals. One by one they harvested her

heart, lungs, liver, kidneys, spleen, pancreas, lymph nodes, femurs, tibias, clavicles,

saphenous veins, and eyes. As they pored over her naked body, I could not help but

wonder why she had painted her toenails on Saturday or why she had taken the time

to lie in the sun, as a tan line revealed on the skin between the patella and the head

of the femur. Didn't she know she was going to die on Tuesday? I am not prone to be-

lieve in ghosts, reincarnation, or anything paranormal, but through the long night I

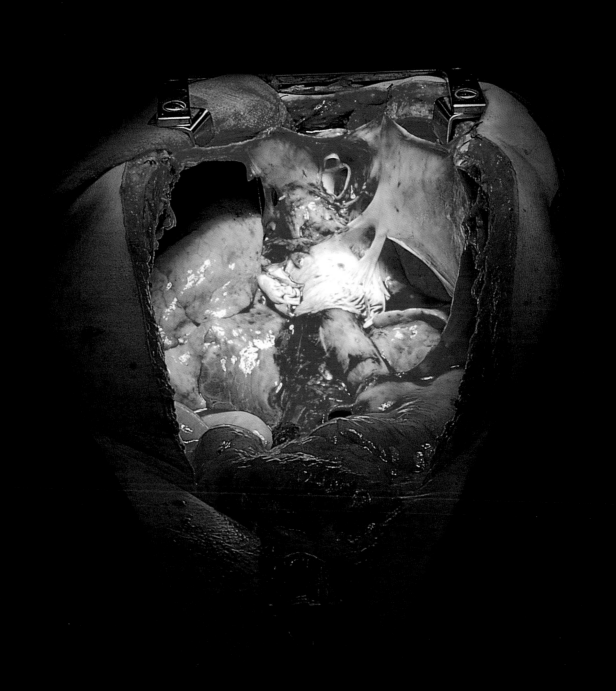

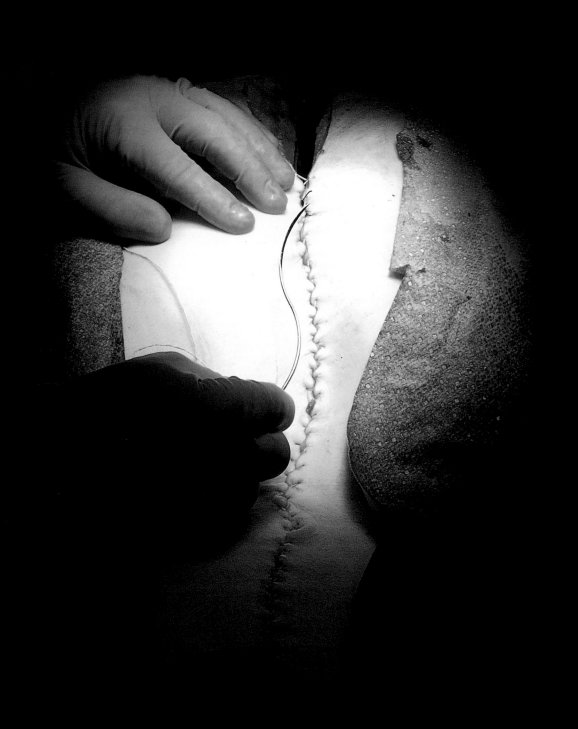

couldn't shake the feeling that she was present. She was there. She was watching. I felt such great, great admiration for her. I thought of her children. How she'd given life to three offspring and was giving herself in death that others might live.

Six hours after we began, her chest was empty, her abdomen vacated, her legs splayed like a Raggedy Ann doll's; PVC piping was laid into the hollows of her legs and cotton balls were inserted into the sockets that once held her eyes. A card listing the donated body parts was checked off, signed, and tagged to one of her toes, lest the mortuary not understand the missing parts. The bone-and-tissue man wrapped her body in a black bag, zipped it up, placed her on a gurney, and covered it with a white sheet. It was 6:30 in the morning. He wheeled her into the surgical staging area, the pre-op, to await transport to the mortuary or a layover in the morgue. I waited with her.

Things picked up, the morning shift arrived, and the first patient was wheeled into an adjacent berth. The nurse scowled at the white-sheeted gurney and angrily yanked the drape, separating the two beds. I felt the insult immediately and realized I'd fallen in love.

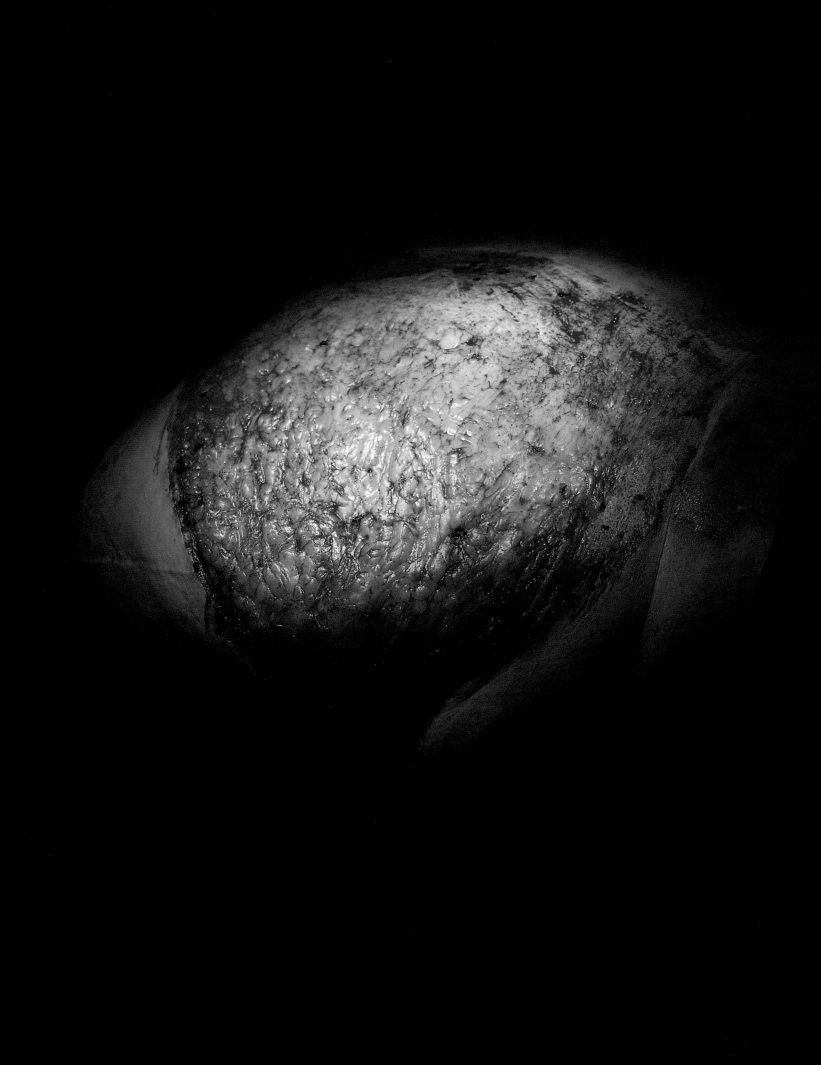

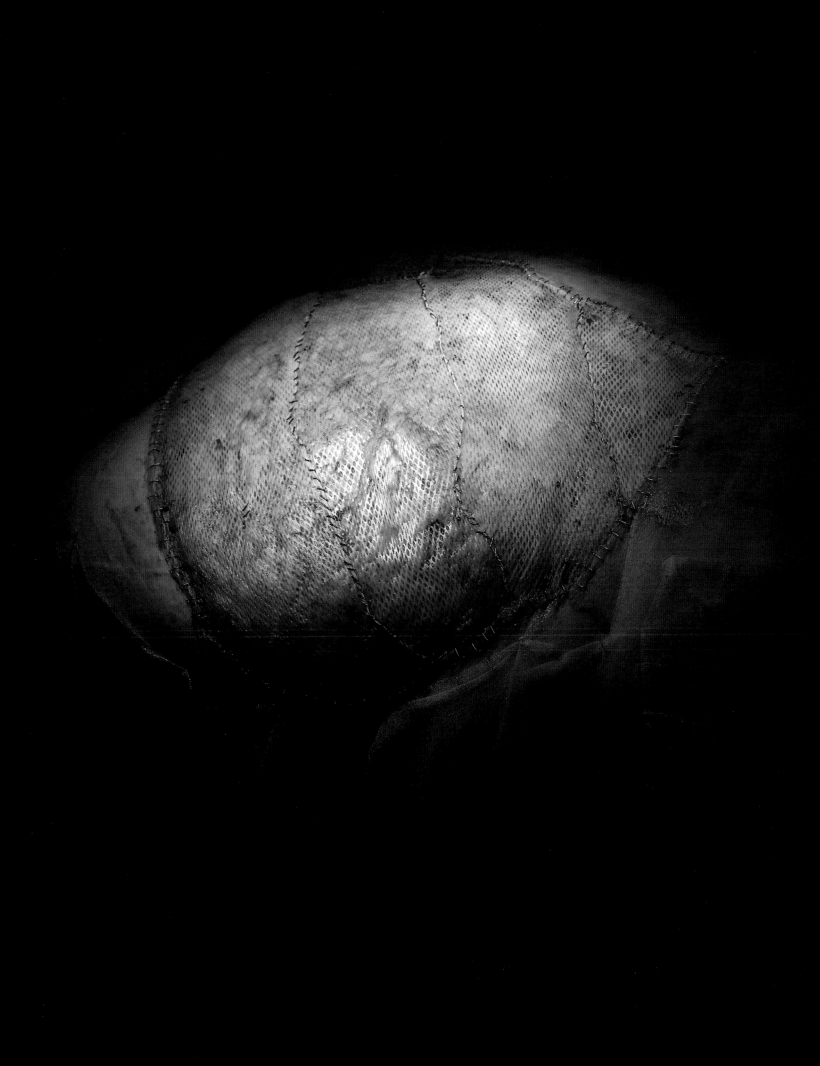

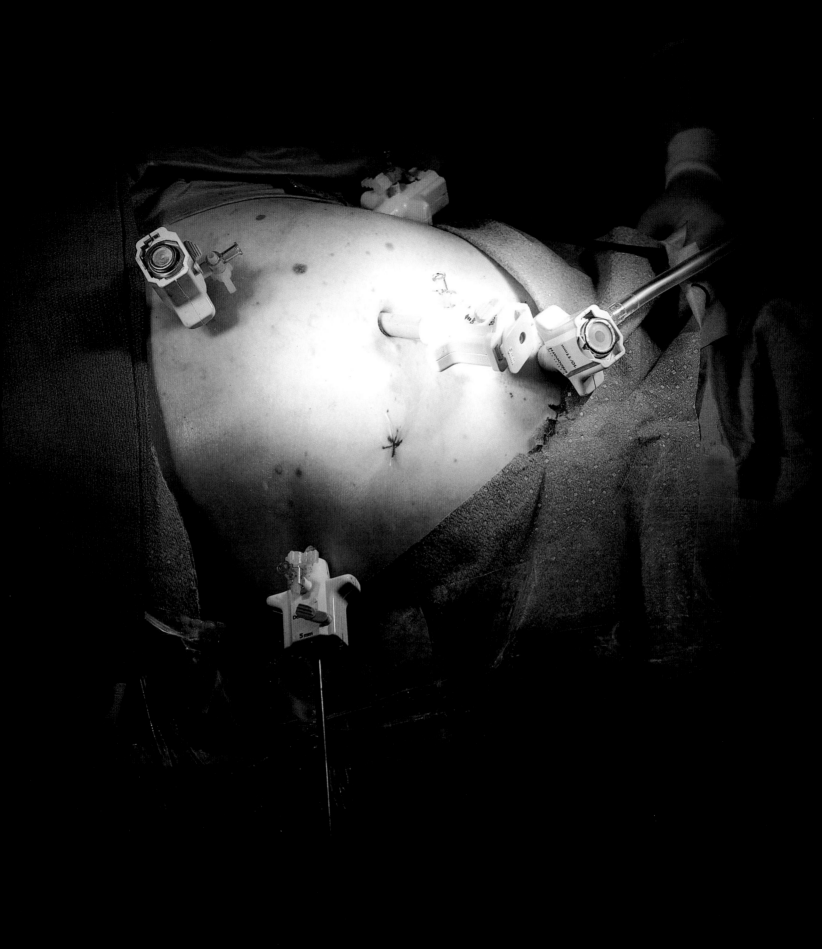

XX & XY

Death. Fear. The sight of blood. To some, these photographs recall surgery they or a loved one has had. To others they vividly bring to life their own anatomy. These photographs remind one not only of illness and healing but of the mysterious and elusive awe of creation. That we function, that there is exquisite order to each and every cell, organ, and fluid, that we can walk and talk and think is absolute genius.

Consider, for example, the greater omentum, a sheet of tissue suspended from the greater curvature of the stomach, covering the intestines like an apron. Known to "police the abdomen" in case of hernia or infection, the omentum moves in like an octopus, unannounced — without the cognizance of its proprietor — and wraps itself around the site of insult, protecting and aiding in combating infection. From where does it seek its function? How does it know what to do? One might as well ask, How does one cell become two? How do two cells become many? How did the original cell begin to differentiate? What makes it become skin, heart, arm, leg, frog, man, or woman?

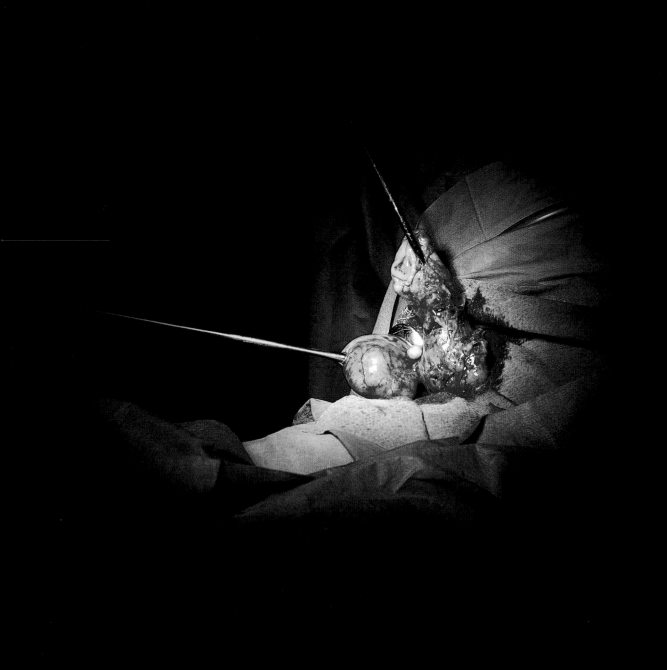

74: *Laparoscopic hysterectomy* 76: *Uterus and tumor removed via the vagina*
77: *Penis with erectile dysfunction* 79: *Penile implant surgery* 80: *Prosthetic device for penile implant*
81: *Penile implant test for function* 82: *Surgeon's finger inside scrotum*

These photographs call into question the very nature of being. They ask, Who are we and where do we reside? Are we in our hearts? Our minds? Our sexual organs? What of the schizophrenic or the victim of Alzheimer's? And what of the amputated limb? A Tibetan monk once told me, "You can slice the body from head to toe in ten-centimeter sections, but you'll never find the soul." If not the questions of a scientist, philosopher, or theologian, these are legitimate inquiries of an artist or of any human being.

Early on, I realized that I could not show these pictures to just anyone. I met some people who reacted to the photographs as I did, but others recoiled, some of them indignant and vulgar; one woman broke into tears. I was often demoralized, but in time, I understood that I needed to continue the project, not so much for those who welcomed the pictures, but for those who could not bear to look at even one. I hoped to provide a visual text by which one might become less afraid of the body, medicine, and, ultimately, less afraid of death.

I am not immune. Often before photographing a procedure, I imagine myself as the patient. I fantasize that I am the one having my leg sawed in half, or that the heart or liver being fondled by surgeon's hands is my own. I close my eyes and breathe deeply until the trembling goes away.

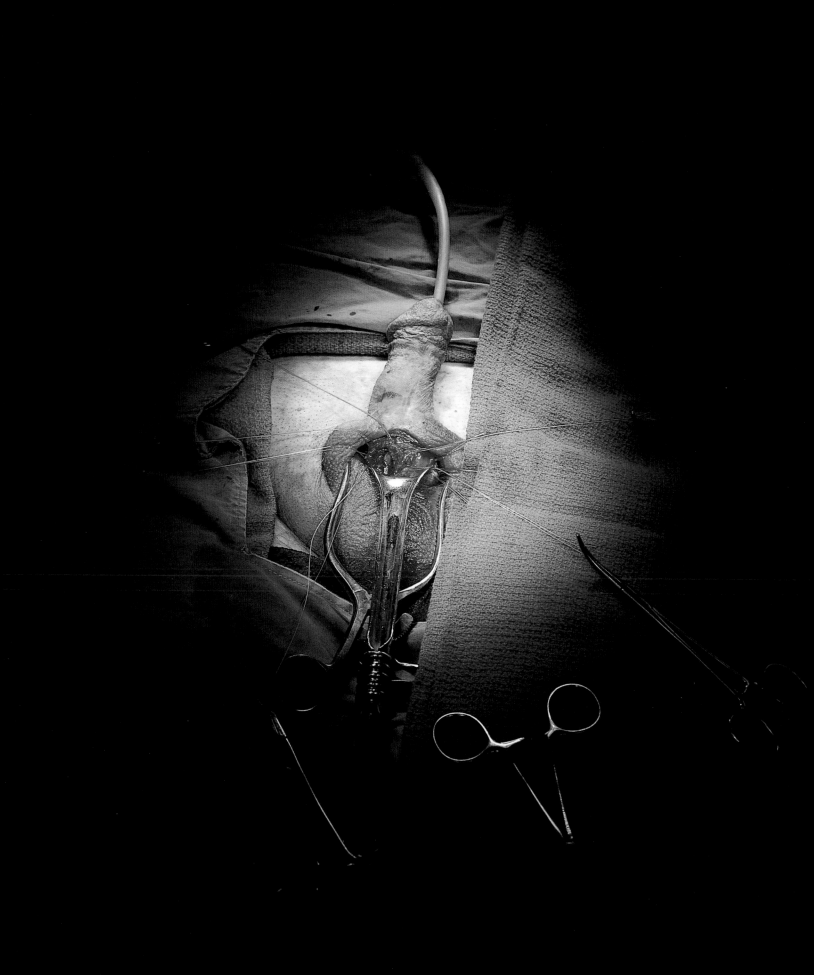

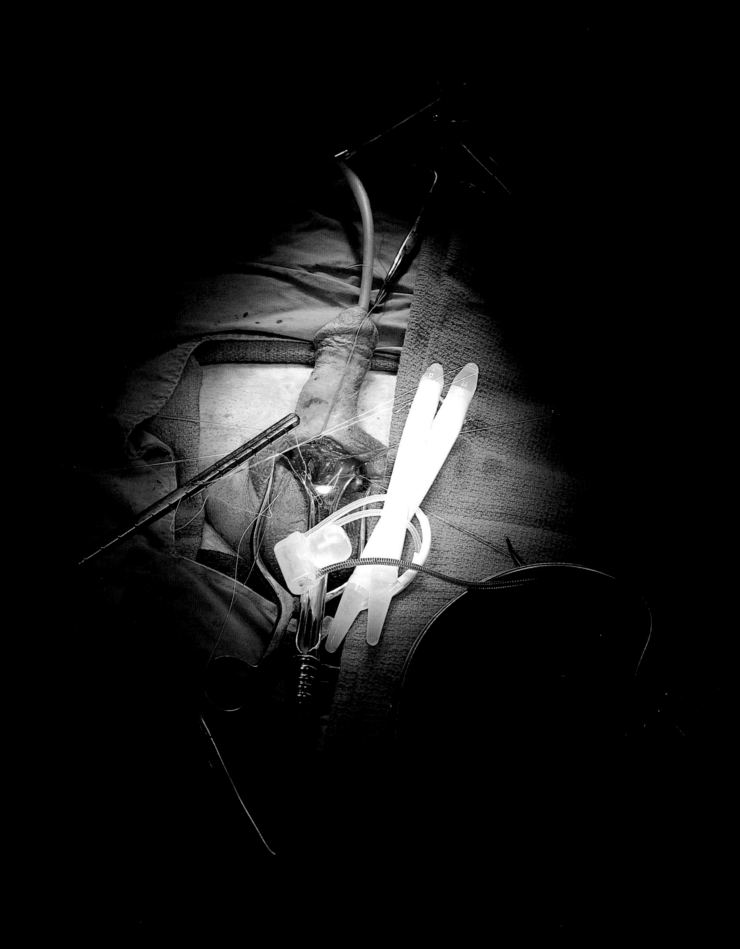

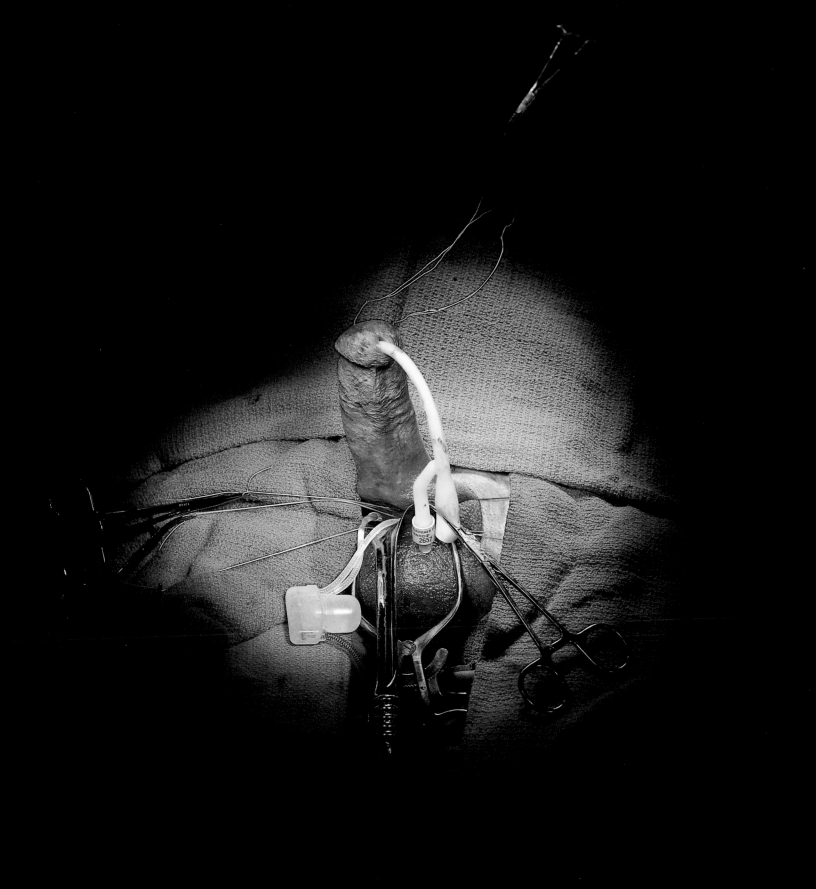

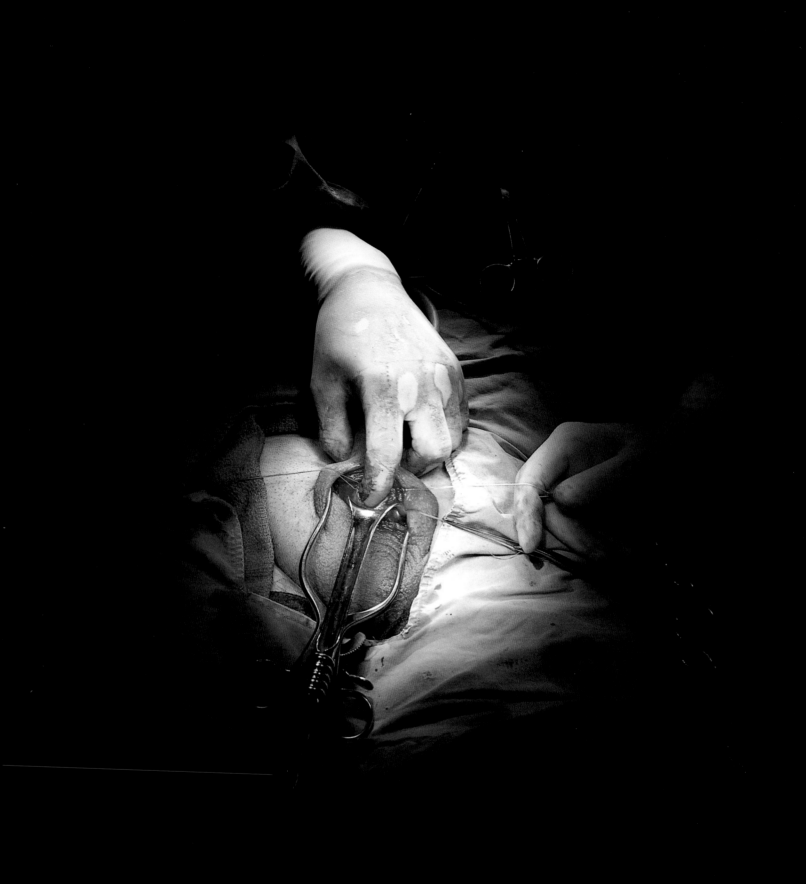

Only in the last five hundred years have anatomists been allowed to perform human dissection without fear of censorship or arrest. Anatomy was considered a pagan science and looked upon with contempt. As late as 1553, the anatomist Miguel Severde was burned at the stake. Not peculiar to Western medicine alone, human dissection was forbidden in ancient China and India as well.

Wounds sustained in battle and the slaughtering of animals provided some crude anatomical insight and must have given occasion for reflection on the structure of the human body. The viscera — brain, heart, lungs, liver, and guts — most certainly were recognizable, even without systematic knowledge or recognition of pathological conditions. Trephining — the boring of holes into the skull — is known to have been practiced several thousand years B.C. to allow egress of evil spirits and to cure strange behavior and headaches.

A great deal of dissection and surgery was carried out by executioners in the Middle Ages. In accordance with laws that permitted torture, hangmen were engaged not only to execute, but to experiment on human beings. It was their task to break

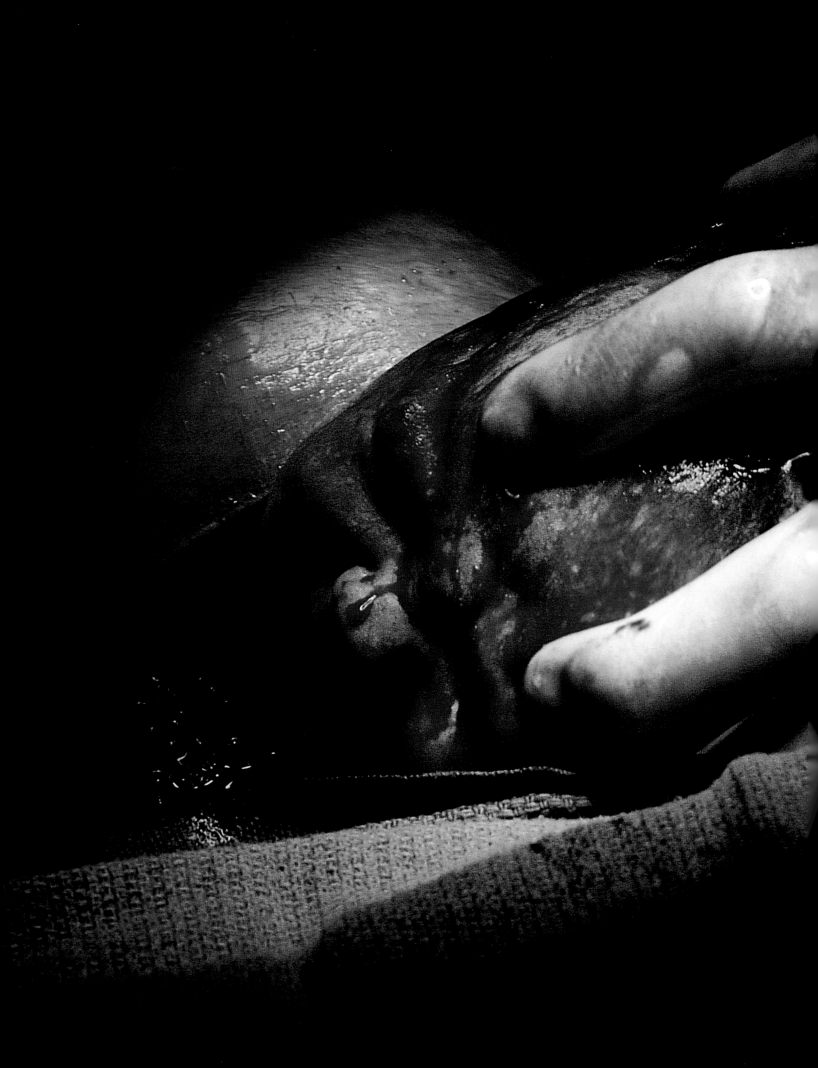

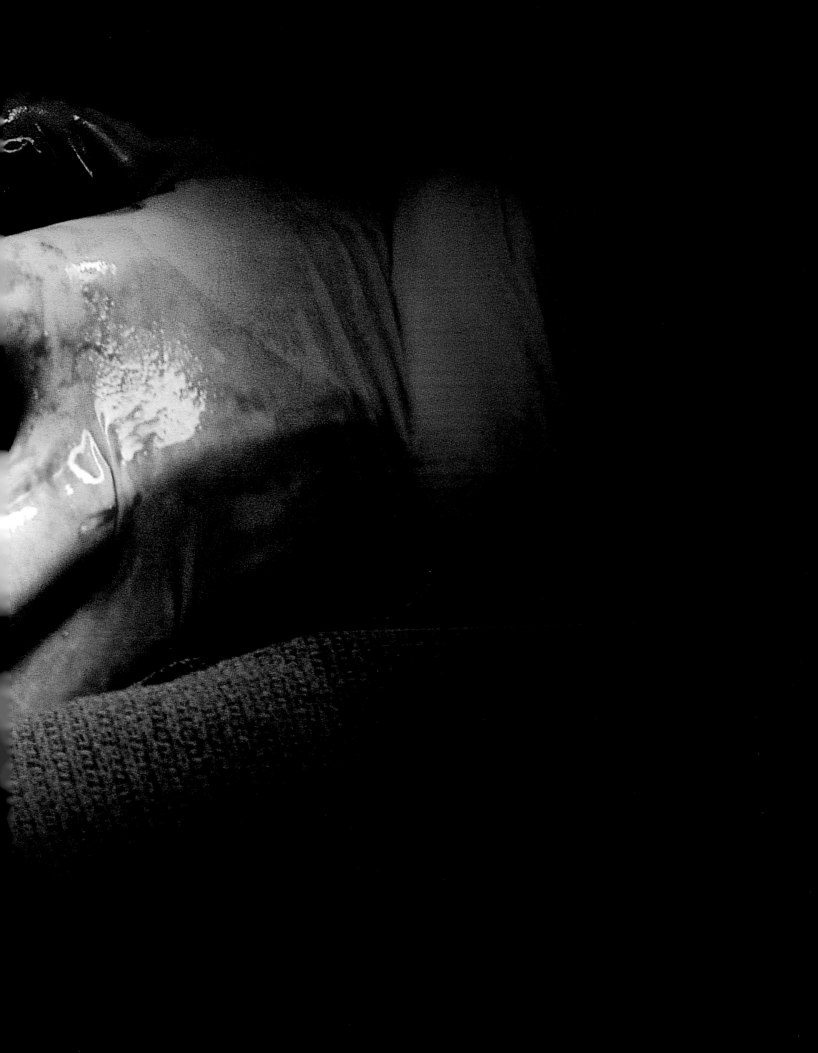

84–85: *Cesarean birth* 87: *Cesarean birth*
88: *Siamese twins joined at the chest* 89: *Siamese twins: administering anesthesia*
90: *Siamese twins: the separation*

bones and reset them, to dislocate and replace joints, to burn the flesh and heal the burns. Then fresh torture could be imposed. Later, the bodies were left on the side of the road so that passersby would be deterred from a life of crime. There was considerable anxiety about dissection of the human body for fear of the consequences upon resurrection.

Human dissection was officially made a part of study at the medical school in Bologna in 1405. Still, bodies were hard to come by, so grave robbers were employed. Anatomy lessons were conducted in an amphitheater where a proctor couched on a raised platform recited the text of the Greek physician Galen, while a hired barber or butcher did the cutting. Since the second century A.D., the syllabus of Galen, who never performed a human dissection, had ruled not only the study of anatomy, but diagnosis and treatment as well.

In the sixteenth century scientific inquiry coincided with artistic endeavors to paint the most perfect human form. Artists began to attend dissections and paint the

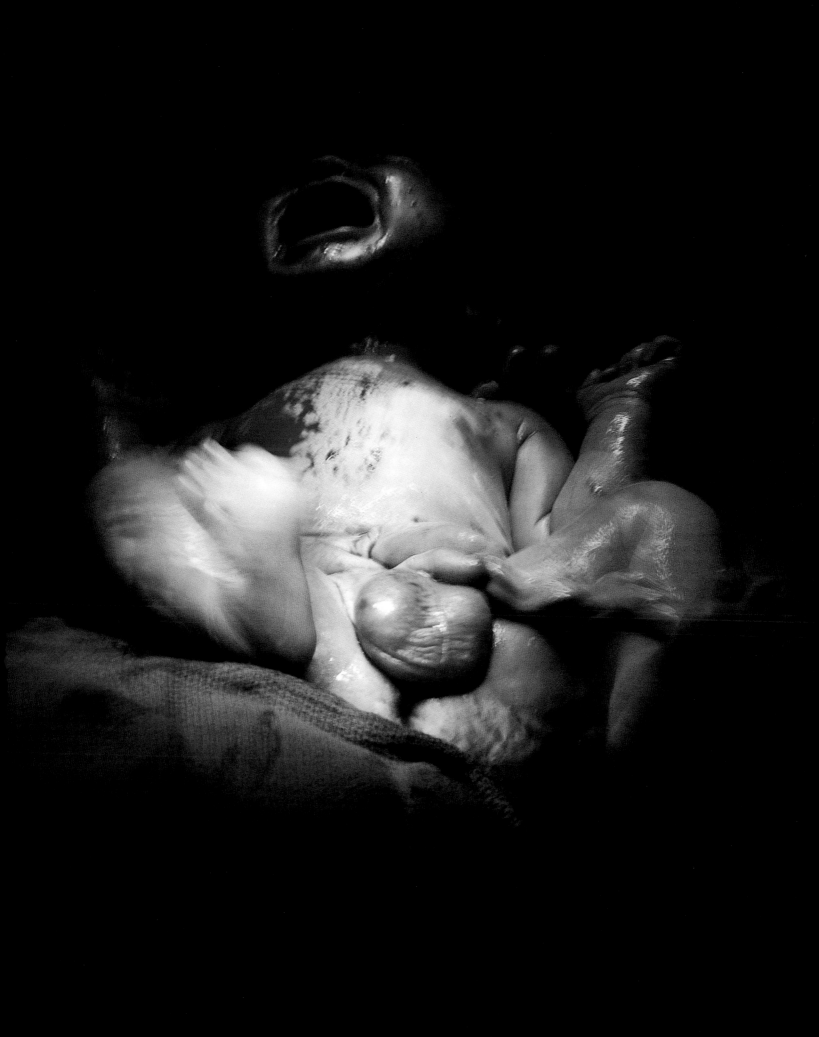

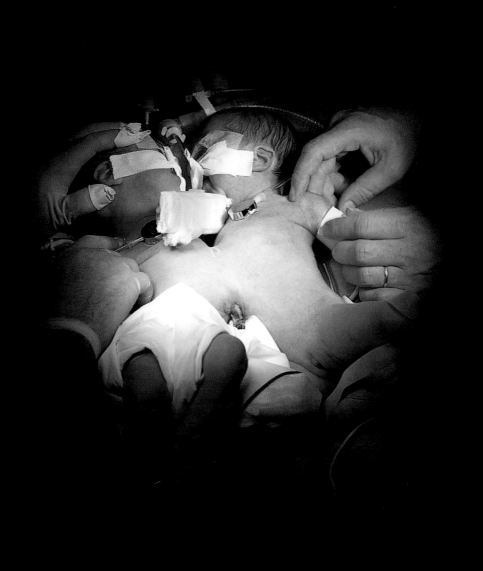

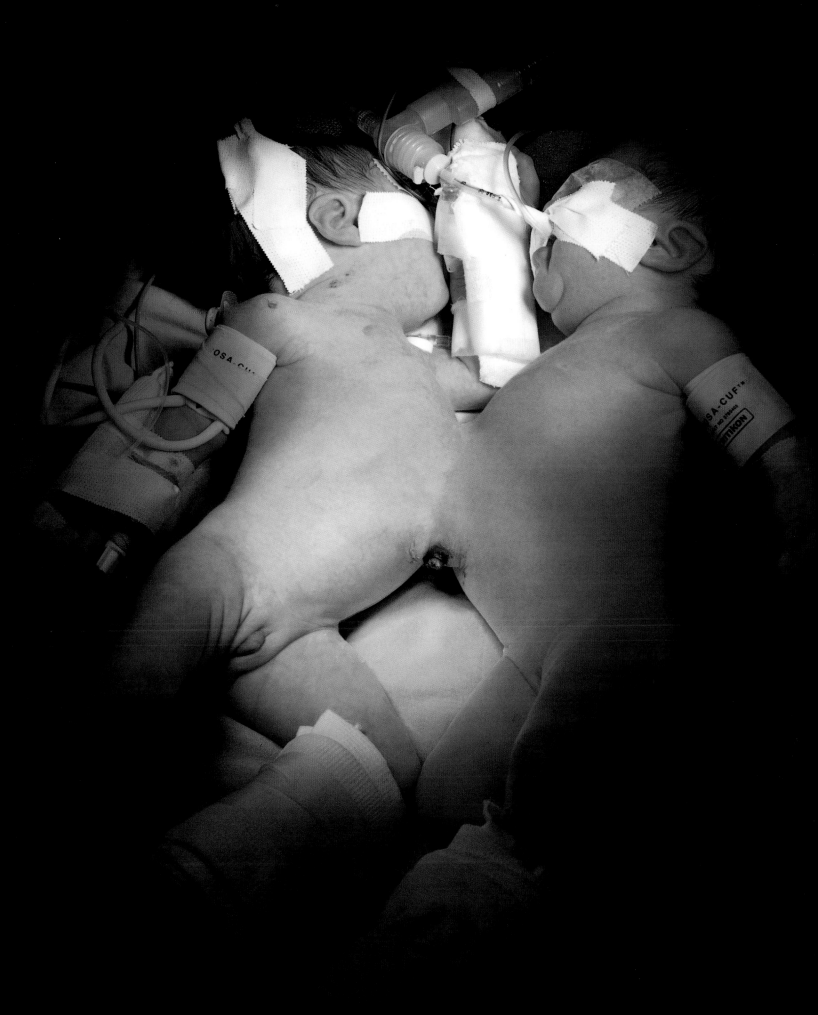

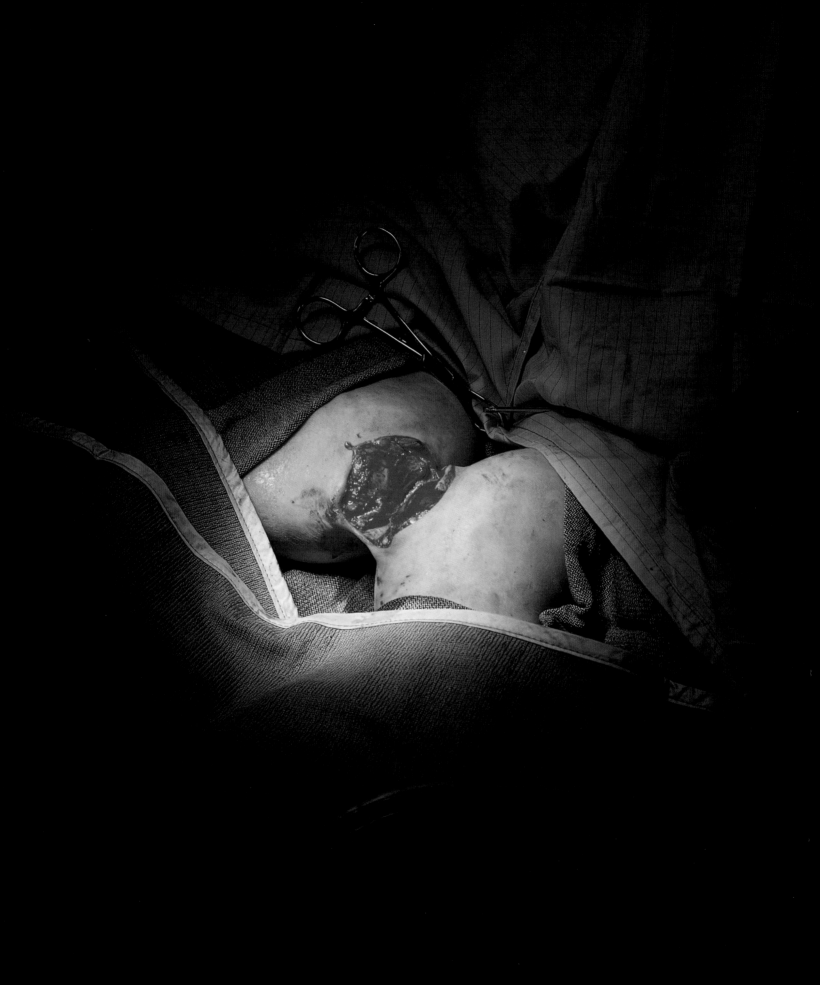

truth of what they saw. Donatello (1386–1466) was probably among the first, followed by such artists as Andrea Mantegna and Luca Signorelli, and then the masters—Michelangelo, Leonardo Da Vinci, and Raphael.

Leonardo went further than most; to him it was necessary not only to visualize the human form, but to understand what lies within. He dissected human cadavers by himself at night, in secret, using a sharp knife, chisel, and saw. Though his anatomical texts remained hidden for three hundred years, he is credited with making several anatomical discoveries. Yet despite Leonardo's remarkable observations, he would sometimes falsify what his own eyes saw and bend to the will of Galen, whose model for human anatomy was that of the monkey and the dog. Leonardo was a Galenist until near the end of his career in 1513, when he began to take a position of independence and base his conclusions solely upon observation, seeking biological truth itself.

During the Renaissance a medical student was esteemed chiefly for his skill in abstract argument, for his readiness in citing classical authorities, and for the fluency of his Latin. He might graduate from medical training without any clinical

93: *Ovarian cyst* 94: *Retracting tools: hip replacement*
95: *Femur with bone marrow removed* 96: *Hip replacement*
97: *Gauze soaking up blood*

experience whatsoever. Physicians relied on bleeding, purging, and enemas. Bleed-ing was done by applying leeches to the skin; purging was accomplished with the help of potions that induced vomiting; enemas were given by rectally inserting drugs. The medical records of Louis XIII (1601–1643) show that in a single year he sub-mitted to 47 bleedings, 212 purges, and 215 enemas.

Traditional surgery was performed by regular barber-surgeons, for whom hair-cutting and shaving provided a solid day-to-day income. Barbers were despised by aca-demic physicians until the French barber-surgeon Ambroise Paré elevated the busi-ness of surgery to a science if not an art. At the siege of Turin in 1537, young Paré ran out of boiling oil and had no cautery (a red-hot iron used to destroy potentially infected tissue and stop bleeding) — standard care for gunshots and burns — so he treated wounds with a soothing concoction of egg yoke, oil of roses, and turpentine. To his surprise, the soldiers whose wounds had been treated with the unorthodox salve were in much better condition than those who had been doctored by boiling oil and red-hot iron the day before.

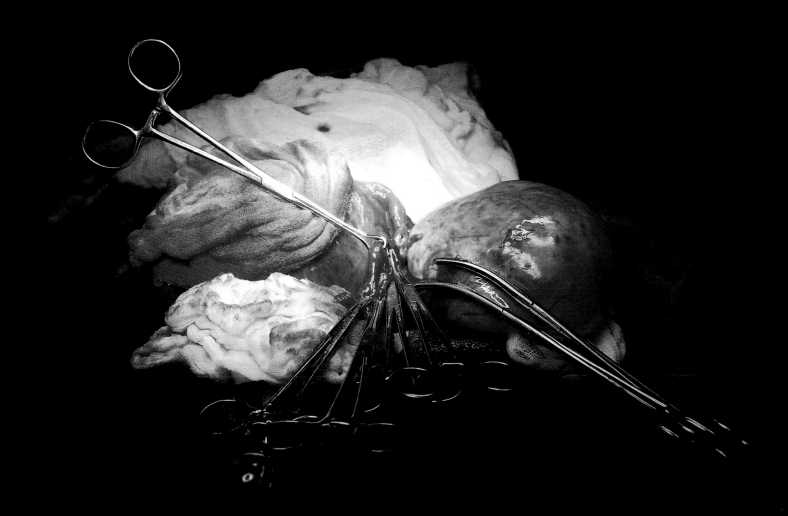

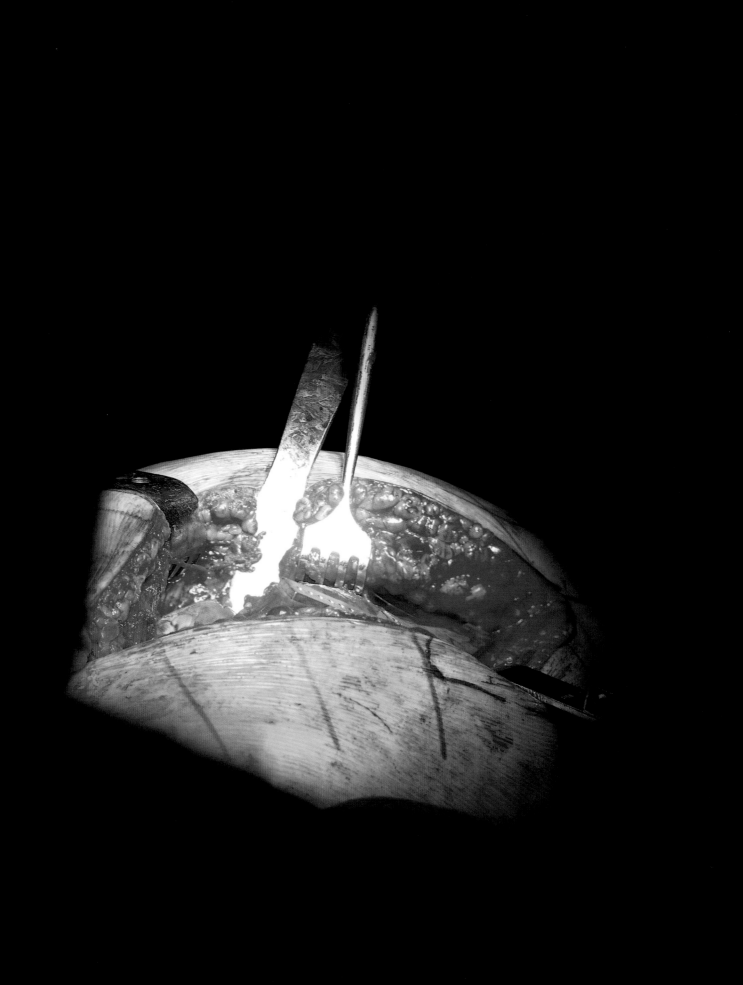

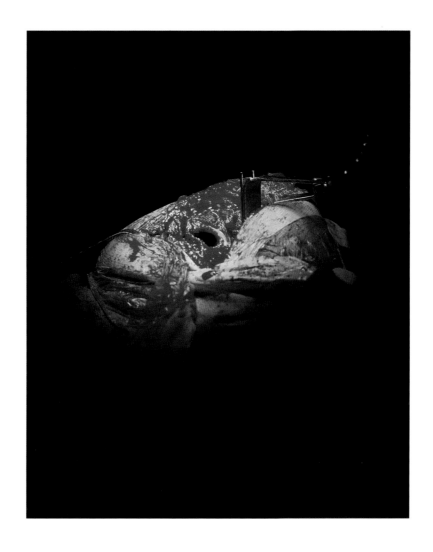

Before anesthesia and sterile procedure were introduced in the late 1800s, a good surgeon was one who was quick; pus, blood, and excreta steadily stiffened their operating coats, which were never washed; the more encrusted they became, the more hallowed and capable the surgeon was considered. Today we live in a world in which organ transplants are commonplace and gene therapy is on the verge of becoming the standard of care. Despite claims of alternative medicine — holistic, homeopathic, New Age, and traditional healing — I question the notion that Western medicine, the art

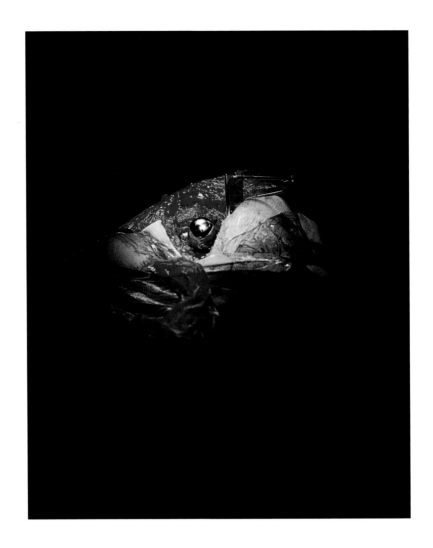

and practice of surgery, are any less spiritual. If God exists, then the discoveries, the research, the scientific developments of medicine and surgery, are the result of a divine hand. To quote Ambroise Paré, "*Je le pansiat; Dieu le guarit*" ("I treated him; God healed him").

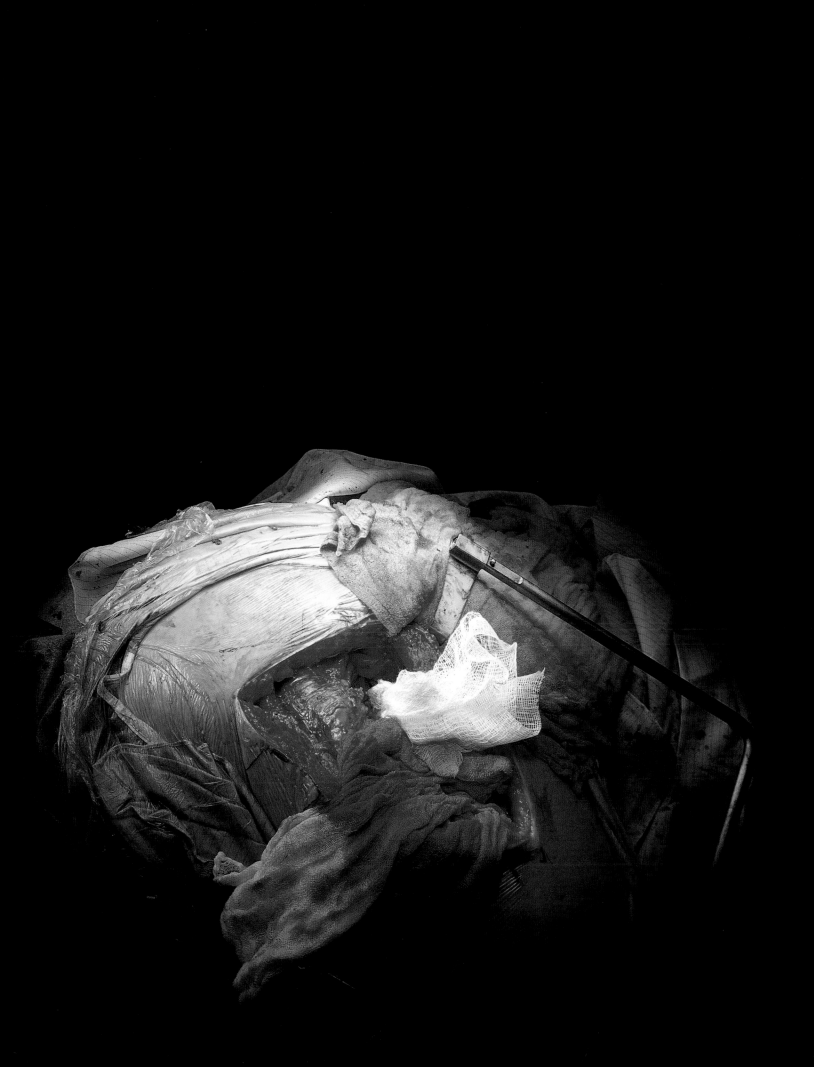

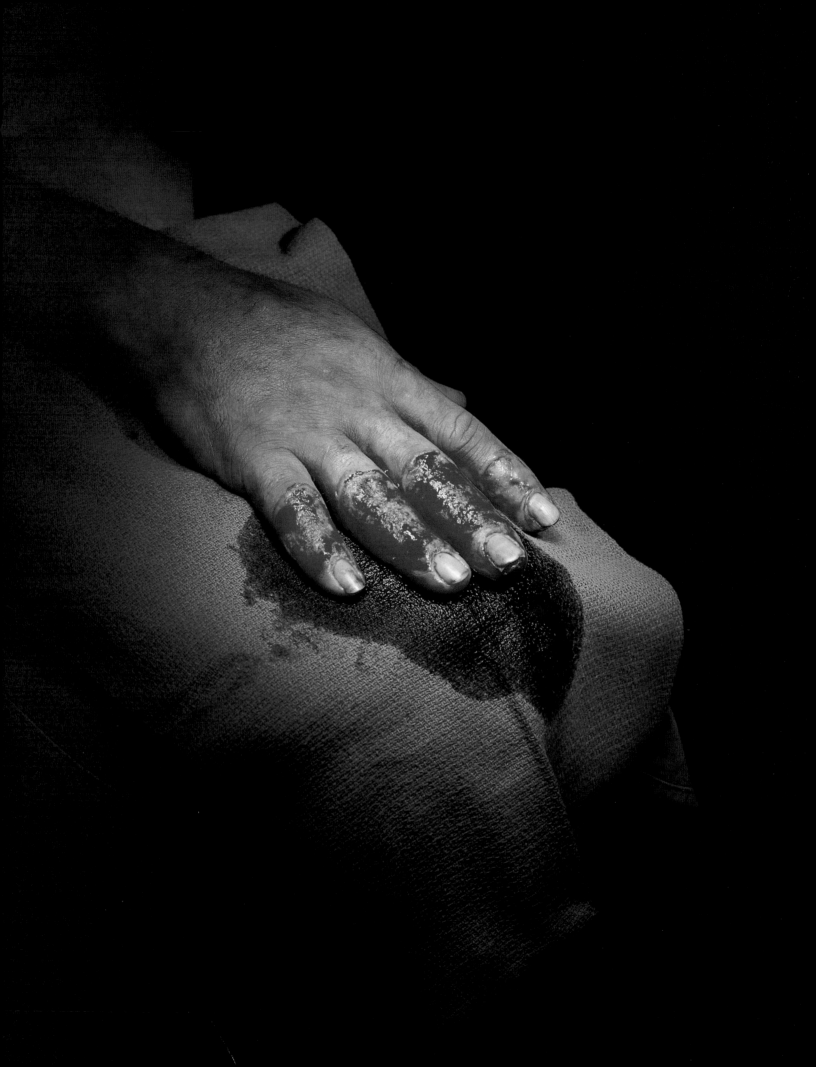

EXTREMITIES

One Sunday while I was having coffee at a diner with a friend, a man doubled over at his table and fell to the floor. Twenty minutes passed as we waited for paramedics to arrive. Every few minutes, the management would plead for anyone who knew CPR to help. I had been a lifeguard as a teen and kept telling this to my friend. Finally I walked over, bent down, and began resuscitation. Not remembering, not knowing for sure, I lifted the back of the man's neck, pinched his nose, and gave him a couple of breaths. I put my ear close to his nostrils to check if he was breathing. I looked at his chest to see if it would rise. A tall, thin man stood over me and bellowed, "That's not the way you do CPR!" A policeman arrived and took over. Finally, the paramedics entered. They applied oxygen, began cardiac compressions, injected adrenaline, and defibrillated the victim three times. He was dead. Forty-five minutes had passed. His face and lips were blue.

Just a month before, I had seen Siamese twins being separated, and two weeks after that, a quadruple bypass. Despite all of my experience in the OR, I couldn't save the man's life. I felt a sense of dread I hadn't known before. It was failure and loss,

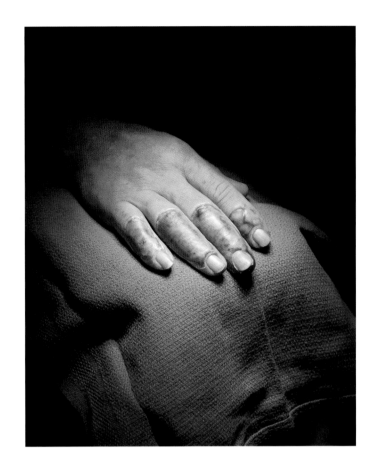

what a young doctor must feel when he loses his first patient. Later, after the paramedics took the body, I found the bathroom and rinsed my mouth out with soap. What I couldn't wash away was the whisker burn the dead man had left on my lips.

Who would understand the profit of spending an evening at home with a father accused of raping his daughter or an afternoon with a woman who claimed to have fifty-three distinct and separate personalities? As a photographer, I have witnessed things that few would care to know or even claim. But

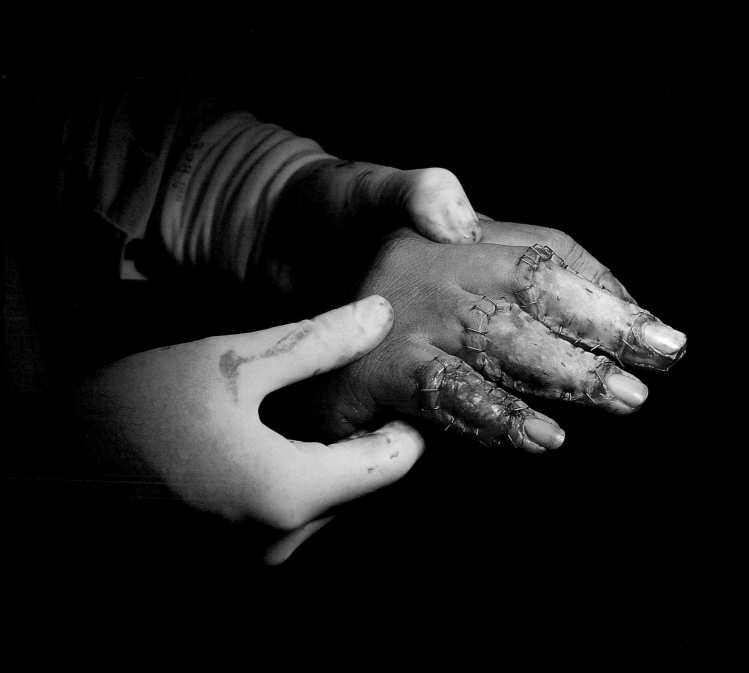

whom could I tell? Who would understand how these experiences have fed my soul and forced me to look in the mirror? Yet, always the bridesmaid and never the bride. Photographers are voyeurs, standing outside experience, never having the experience itself. Walking the floors of a hospital ward, I was free to stare unabashedly at the wonders and horrors of nature. If only I could cross the line and enter the world itself. If only I could do this every day.

As I move from exterior to interior, from the world around us to the world inside, from photographer to anatomist, to the doctor I hope to become, my quest remains the same. When I'm taking someone's portrait, my subjects ask me, "What do you want me to do?"

"Just do what you're doing," I tell them.

"What do you want me to wear?"

"Just wear what you're wearing."

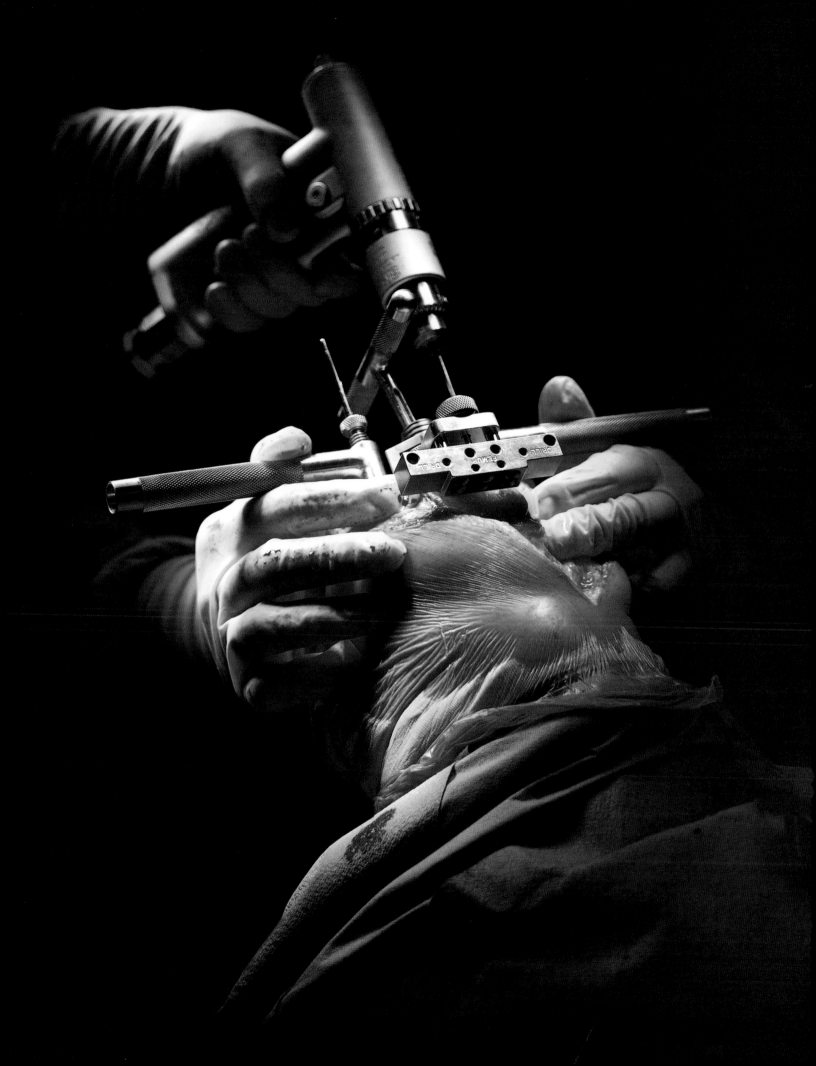

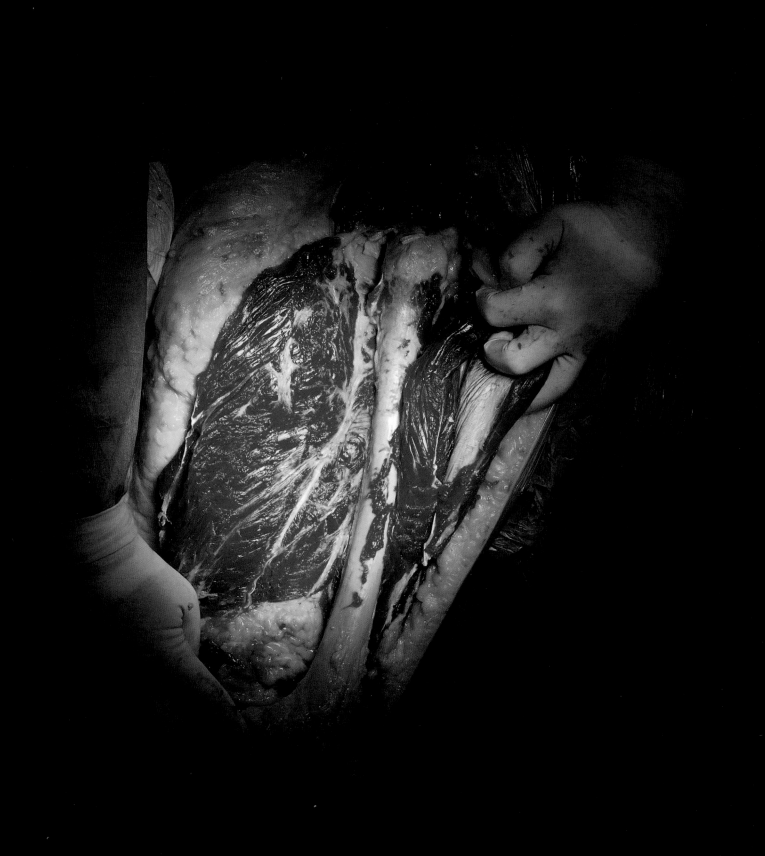

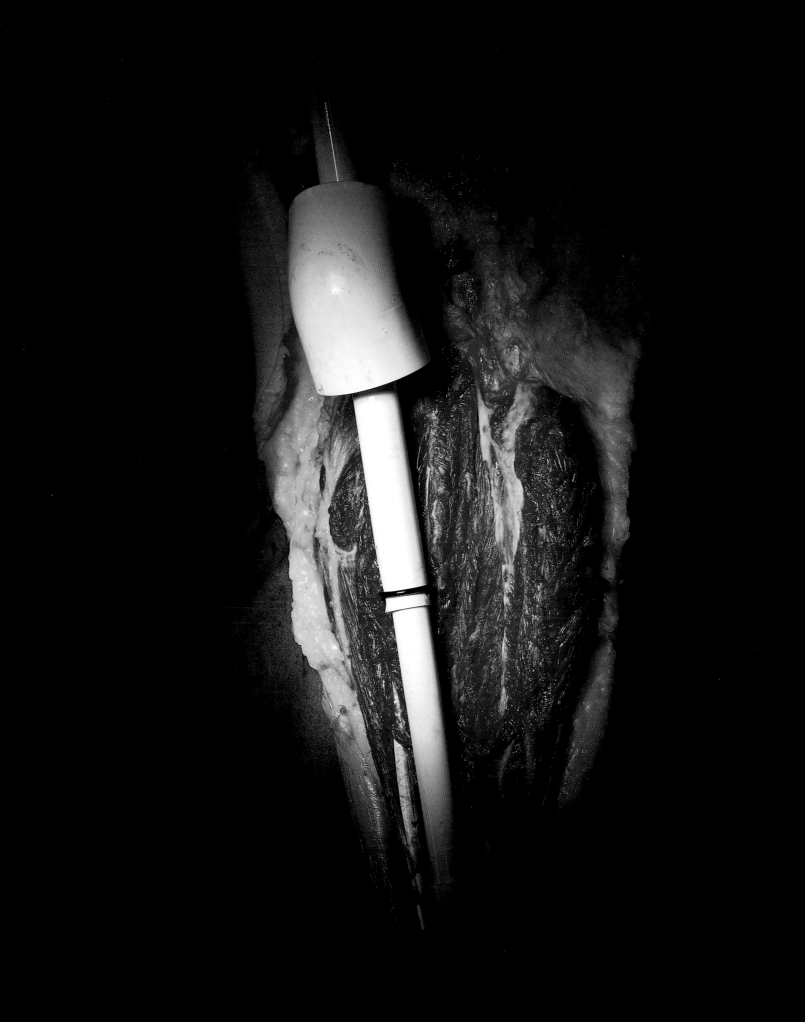

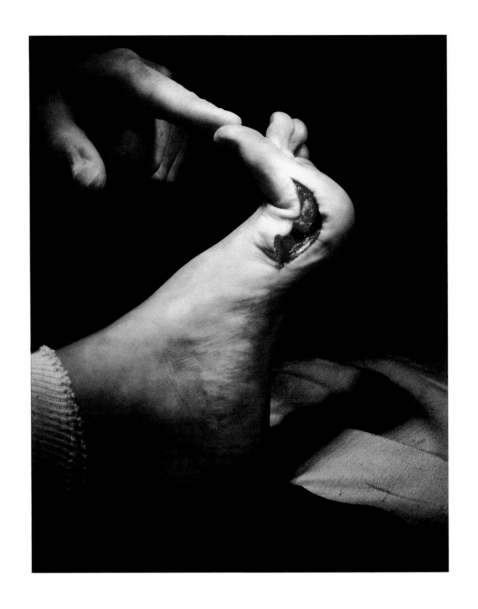

"What are you trying to photograph?"

"Your soul," I say, half kiddingly. "I'm trying to photograph your soul."

Where before I searched the eyes of a man, the wrinkles of his clothes, the wear and tear of his shoes, I look now in the recesses of his flesh, the color and texture of his liver, the markings and capacity of his lungs.

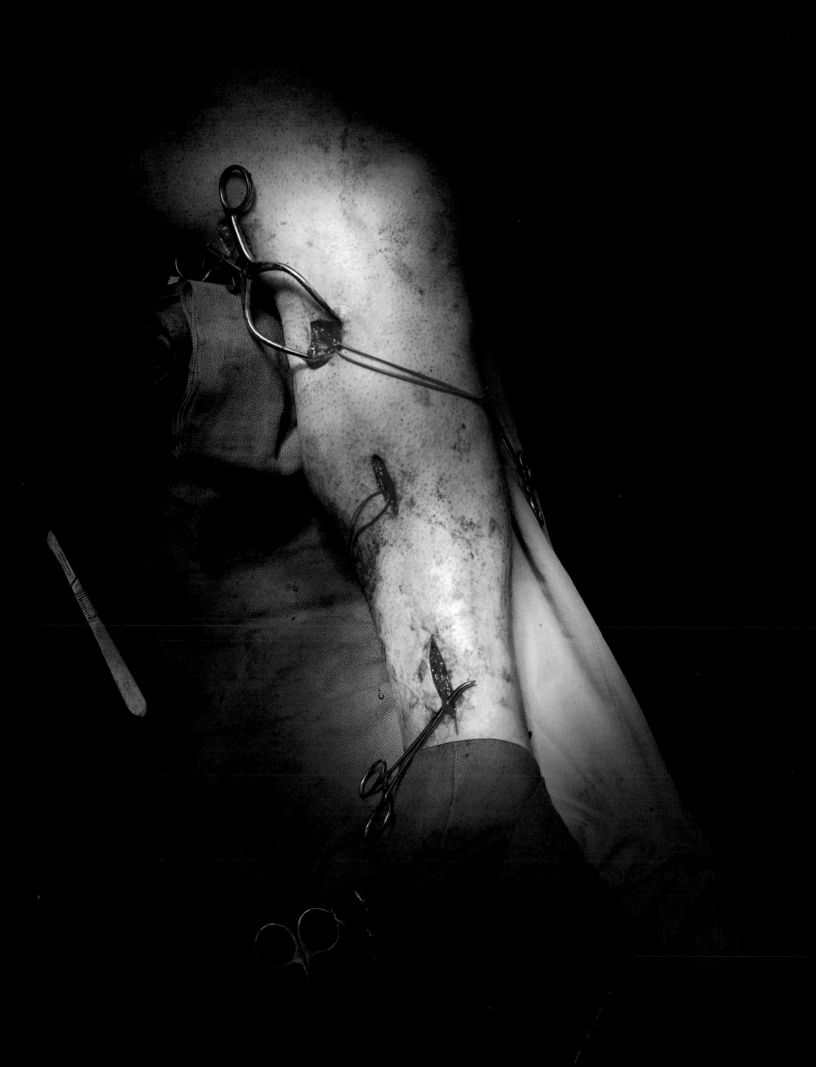

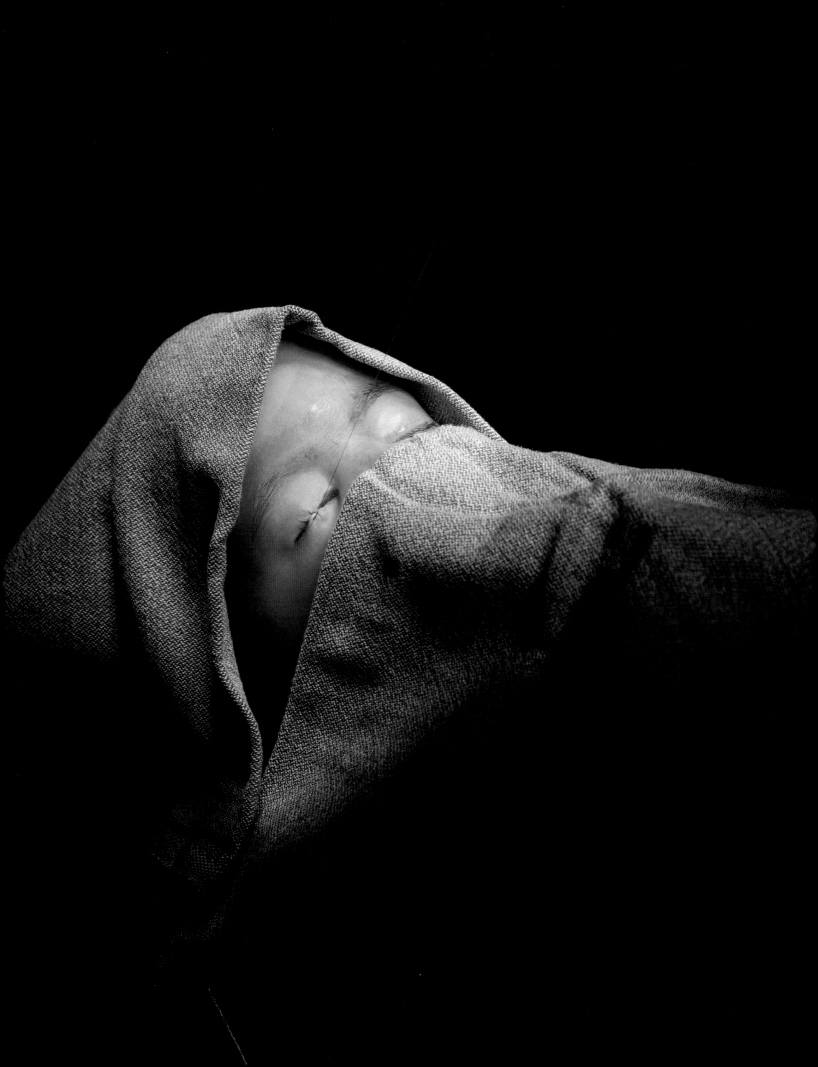

EPILOGUE

We often think of the soul as our heart and the heart as our soul and that death occurs the moment the heart stops beating. But in a heart transplant, the donor heart when removed is still beating. It must be. In fact, it has to be injected with a drug and packed in ice just to calm it down so it will have enough energy to kick in and start over. In this manner, the recipient receives the very heartbeat, the rhythm of the donor.

In the operating room, as parts are removed, replaced, salvaged, or exchanged, the body is just a vessel. The anesthesiologist controls your blood pressure, your breathing, your ability to sense pain. You can't speak. Your eyes are taped shut. Your thoughts, your memories, your dreams are adrift. Where do they go?

Max Aguilera-Hellweg
NEW YORK CITY, MARCH 1997

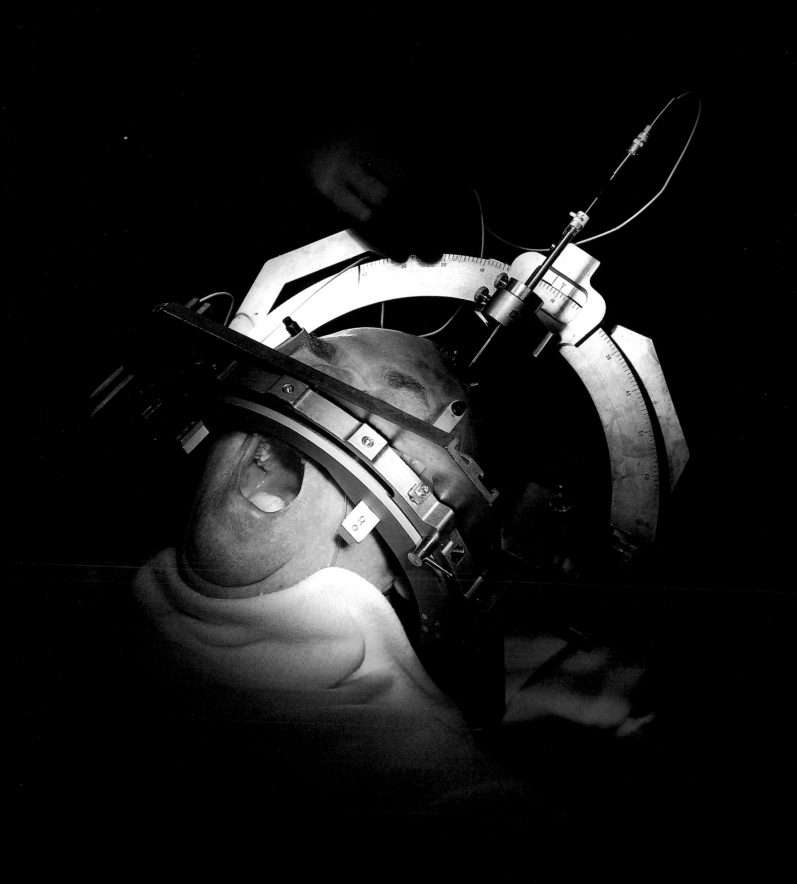

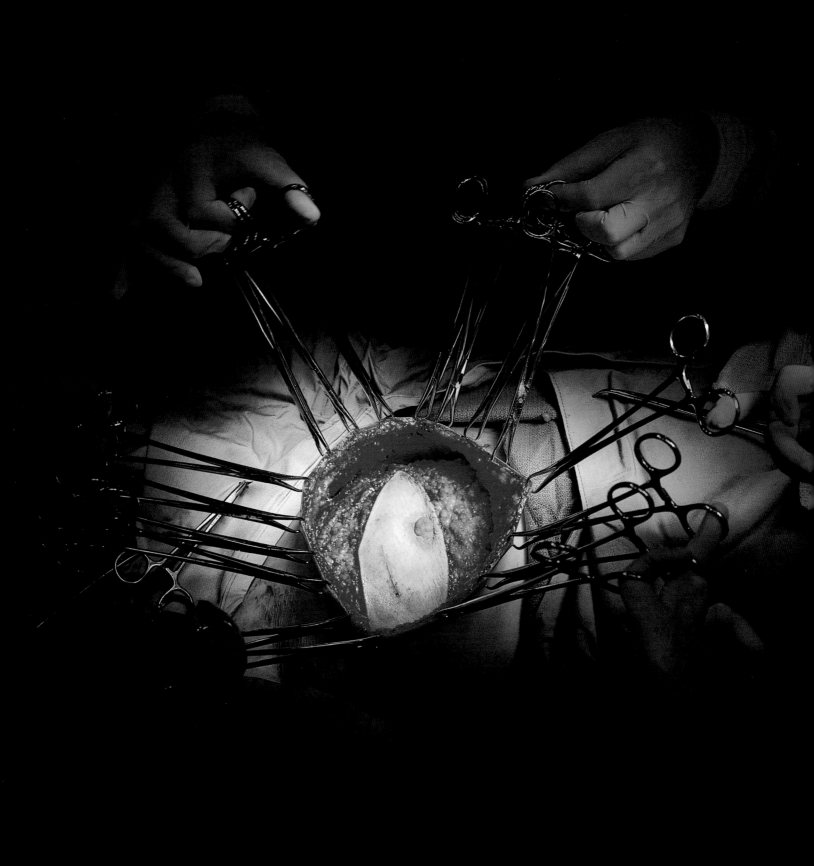

THEATER OF OPERATIONS

A. D. Coleman

I count these photographs by Max Aguilera-Hellweg among the most beautiful and horrifying I have ever seen. Sometimes, as I make my way through them, I think they're ravishing, exquisite, in a league with the *vanitas* still lifes of the Dutch masters and oddly parallel to those lambent broodings on mortality. Sometimes, when I look at them, I break out into a cold sweat. Sometimes both at once.

The first time the photographer showed me his maquette for this project — at Houston FotoFest in the late winter of 1994 — I volunteered within five minutes to write an afterword to this book, then in the early planning stages. The next time I saw them — about eighteen months later, greatly enlarged, projected as slides on a screen for a lecture he gave at Columbia University — I grew faint with no warning, began to shake uncontrollably, and came close to passing out in a darkened auditorium full of rapt pre-med students. Only putting my head down between my knees, breathing deeply, and listening to Aguilera-Hellweg's high, sweet, excited voice describing the experience of making them brought me around.

These pictures evoke, at least for me, a form of existential free fall. On one hand, they function as pure documentation of state-of-the-art invasive surgery, made under conditions that, from a strictly technical standpoint, precluded almost any interpretive activity on the photographer's part. On the other, they construct a highly charged, life-and-death scenario symbolically yet also literally acted out by a cast of medical instruments, gloved hands, and body parts in a few square feet of space. On this small stage, in a tight circle of concentrated light, the blade of the scalpel defines the cutting edge of that eternal philosophical query, re-

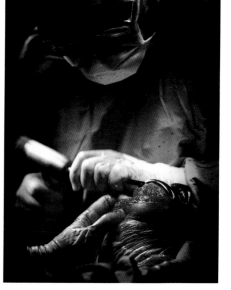

peatedly drawing the line between soul and flesh. If, in bringing us face to face with those acts and the spiritual issues embedded in them, these images do not induce the fear and trembling of which Kierkegaard wrote, then I think they have not truly been seen, *felt,* by the viewer.

Had these relentless penetrations of the body taken place without consent, we'd call them rape. Were their purpose other than curative, we'd consider them assault with deadly weapons, attempted murder. Performed with less skill, they'd be mere butchery. These images do not shy away from those possibilities, yet what they describe cumulatively speaks of vulnerability and trust, and a profound love for each other and for our lives on earth, out of which this craft and science grew. These are indeed, as Paul Simon sings, "the days of miracle and wonder," when "medicine is magical and magical is art." Aguilera-Hellweg's pictures open up before us a space triangulated by those three systems of thought — medicine, magic, art — yet leave the decision as to which is which, and when, entirely up to the individual viewer.

The evolution of invasive surgery over the past half-century has transformed our concept of medicine, and of the physician — particularly the surgeon. The questions raised by the newest surgical techniques and technologies have extended themselves so obviously into the territories of ethics, morals, philosophy, religion, that we now debate them not only in scholarly journals and med-school seminars but in the editorial pages of daily newspapers, on radio and television talk shows, and via feature films and prime-time television surgery-centered dramatic series like *Chicago Hope* and *ER*. Much of that discourse, typically, comes to us contextualized by the social, embedded in the personalities of this or that real-life surgeon or else some actor who, though neither a

doctor nor a patient, plays one on TV. Thus our perception of what they're about becomes enmeshed in our personal response to them as agents — real or simulated — of these radical intrusions into our physical selves. It's important to note, too, that these representations are mostly kinetic, indeed often hyperkinetic (especially those set in emergency rooms); moving images of high-speed events with raucous sound tracks, they simply do not encourage or even allow the quiet meditation that the underlying issues demand.

So Max Aguilera-Hellweg performs two extremely useful services for us in this extraordinary suite of photographs. First, by choosing to address these processes and experiences through the medium of still photography, he immobilizes notable moments in the flow of these medical events, renders them fixed, static, iconic, available to us for contemplation at length. Within an arena of necessarily efficient, rapid, and sometimes frenetic activity, he encases his thoughtfully selected glimpses in cocoons of slow time. Second, he strips away the comforting narrative element within which accounts of such operations most commonly come to us. Elsewhere in this book you will find tales of some of these

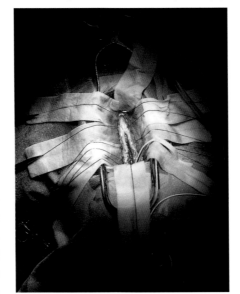

procedures and a list of the physicians involved. But, in the microcosm constructed by these pictures and their brief titles, neither these physicians nor their patients have names, faces, identities, stories. So, as we engage with these images, we have no one with whom to identify — except, of course, the actual living bodies undergoing these ruptures, alterations, and sutures, which we cannot help but imagine as our own.

Yet, notwithstanding their function as literal (and absolutely fascinating) reportage, there's a poetics operative in these pictures as well, something that transcends neutral witnessing and becomes a form of bearing witness to the miraculous as it takes place before the photographer's eyes. In coming to terms with them, it's vital to understand the restrictions under which they were made. Much of the way these images look — the events depicted, of course, but also the quality of light, the color, even the edge of the frame created by that circle of illumination — lay well beyond the photographer's

control. That would seem to cast this project unequivocally into the territory of the strictly recordative.

Yet Aguilera-Hellweg has turned many of those strictures to his own advantage as a poet. True, the vignetting effect results not from the photographer's aesthetic choice but from the light source concentrating on the area of the body under exploration, a light so intense that, in the resulting photographs, everything else falls away into darkness. Yet, fortuitously, this creates a visual equivalent to *tunnel vision*, that "dying of the light" experienced by many people in dream and trance states, as well as while actually dying and (according to reports) during near-death, out-of-body experiences as well. Consequently, it seems to me, in these images we get something roughly akin to the body's own experience here, as if one's spirit were watching one's own body under the knife.

In this way, and in others, the photographer's vision asserts itself here: his sense of astonishment, of curiosity, of reverence, and of awe emerge palpably from these pictures, as does his perception of this process as what one might call a "theater of operations," with the surgery table as proscenium, the body and its components as dramatis personae, the hands of the medical team as deus ex machina, the limitations and transmutability of flesh the key issues. From the flux and complexity of these amazing operations, Aguilera-Hellweg has extracted a set of breathtaking production stills, a sequence of pictures at once purely descriptive and deeply creative, ghastly and sacral, resonant with holy terror. They push the envelopes of documentary, creative, and medical photography in profoundly provocative and useful ways. I knew before I first saw them that Aguilera-Hellweg was a documentary photographer with a poetic tendency. It was not surprising to me to learn that, as a result of engaging with this project over a long period, he'd decided to become a physician and enter medical school. I think that only someone with a foot in all three camps could have made these photographs — someone with a doctor's understanding of the events, a documentarian's detachment from them, and a poet's heightened consciousness of their epic implications.

— *A. D. Coleman, Staten Island, New York, April 1997*

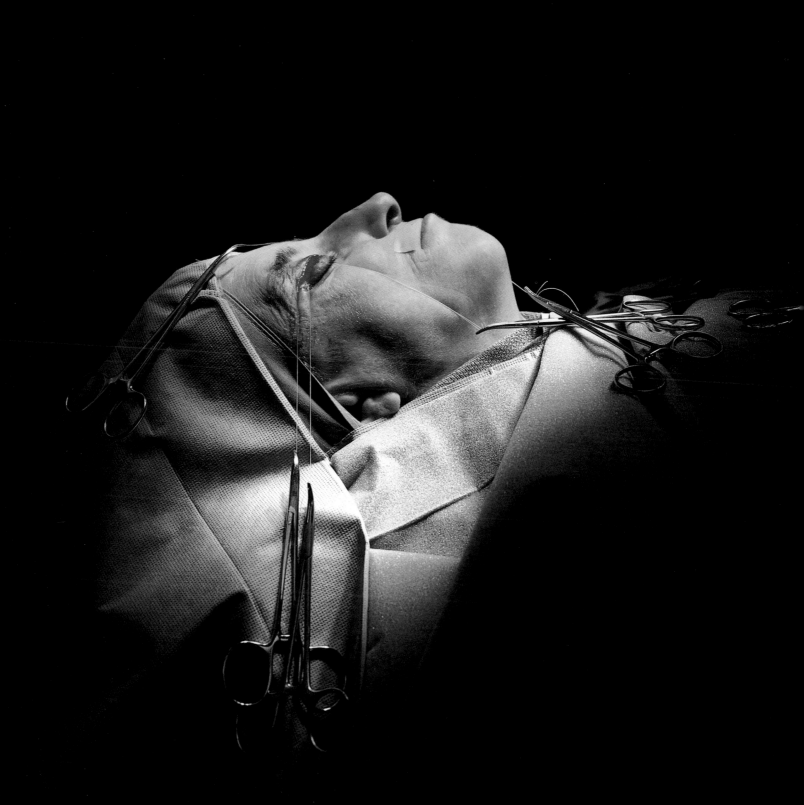

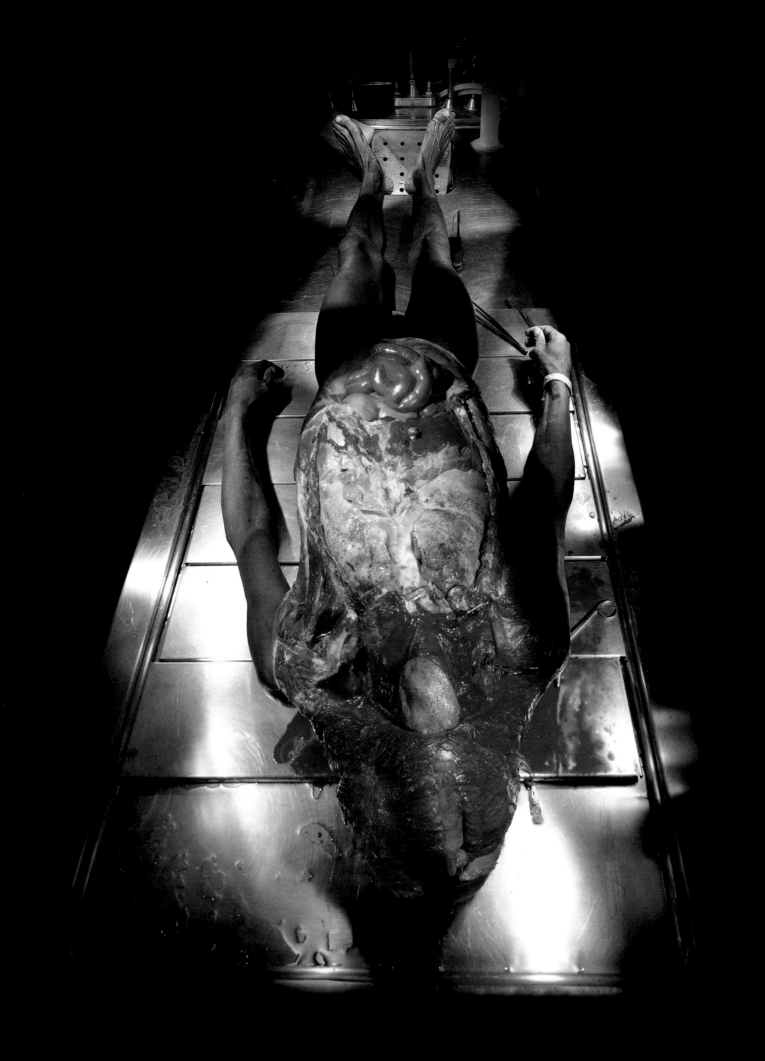

POSTMORTEM

• **2** *Surgeon's Hands.* A surgeon holds his hands close to his chest to avoid contamination.

• **5, 6, 124** *Spinal Cord Surgery* (see page 32). Suffering from a sudden onset of paralysis, a man hangs from a vise clamped to his skull prior to spinal cord surgery. The back side — the laminae, the flattened part of either side of the arch — of five vertebrae was removed, exposing and relieving pressure on the spinal cord. Since the vertebrae were not re-

moved in their entirety, the remaining bone, along with the muscles, formed the basis of support around the compromised site. One day after the procedure, the patient was able to stand on his own and walk around his bed.

• **12** *Eye Procured for Cornea Transplant.* Though the whole eye is removed from the donor, only the disk in the center of the cornea, covering about 50 percent of the pupil, is eventually transplanted in patients who have cloudy or distorted corneas. Cornea

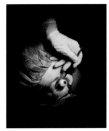

transplants are the most common organ transplant done. Over 40,000 are done in the United States each year.

• **13** *Surgical Instruments for Rhinoplasty* (Surgery of the Nose).

• **14** *Removal of Plaque from the Carotid Artery.* One might be surprised in the operating room to hear surgeons ask each other, "Do you think this is the vein?" "No." "Over there. I think it's that one." The trouble is, a vein can sometimes appear to be something else. In this

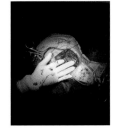

particular operation, the patient's external jugular vein, to be used as a patch on the carotid artery, was not where it was supposed to be and a discussion between the surgeon and his resident ensued.

Between one person and another, our anatomy can be just a little bit different — there can be an extra vein or artery, or the position of an organ or vessel can vary. The surgeon then makes an extra effort to distinguish anatomy and structure. Once identified, each structure is tagged with a colored elastic loop and tucked away. During the course of an operation, minor arteries, veins, or nerves may need to be sacrificed, but an important vessel or conduit will generally be saved.

• **15** *Cochlear Implant.* A two-year-old girl who was born deaf has an electronic device implanted into her inner ear, where it will directly stimulate the auditory nerve, sending signals to the auditory cortex of her brain. The auditory sensations possible with such an implant are different from those of normal hearing; to those who once were able to hear, the voices are said

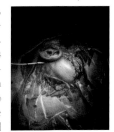

to sound initially like a record at the wrong speed or like Donald Duck. In time, however, the sounds seem more normal. Implants help many deaf adults and congenitally deaf children to understand speech but are controversial in the deaf community, where their use is perceived as a threat to deaf culture.

The white tube visible in the left side of the photograph is a surgical drain, implanted at the end of most surgeries to prevent fluid from collecting postoperatively.

HEAD

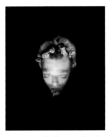

• **16–20, 22–23** *Craniofacial Reconstruction.* This forty-one-year-old woman was born with Crouzon's syndrome, a hereditary birth defect in which the five bones of the cranium grow irregularly — too fast, too slow, or not at all — creating a deformed, if not shrunken, skull and face. Because of the reduced growth of the bones of the orbits, the patient's eyes bulged out and appeared

to operate independently of one another. A CT scan showing the profile of the skull revealed the

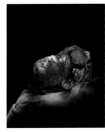

top of the head rising like a ski jump, then falling off at a sheer 90-degree angle at the top of the brow, so that the common curvature of the forehead was missing. The front of the face was flat, with no visible cheek bones.

Before the procedure, to spare the patient the indignity and embarrassment of having her hair shorn, the surgeon rolled up the hair with rubber bands and put tinfoil over the rolls to keep them away from the surgical field. "It's one of the small things we do," the surgeon said. He next made an ear-to-ear incision into the scalp that would be hidden in the hairline. Instead of continuing the incision through the skin of the face, the lower half of the operation was done through the patient's mouth. Alternately peeling back the face and putting it back on, to confirm his progress, the surgeon restructured the bone and gave the patient a new face.

• **24–25, 115** *Bilateral Eyelid Repair.* The repair was done to treat eyelid droopiness and soften the prominence of the upper eyelid fold. It was one of several subsequent surgeries for

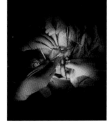

the woman with Crouzon's syndrome.

• **27–29** *Cataract Surgery.* With the patient under general anesthesia (with loss of consciousness

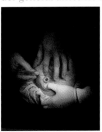

and sensation), a local anesthetic (affecting the nerves and nerve tracts of a small region) is injected beneath the eye. The general anesthesia is turned off, the patient is awakened and kept awake during the procedure. A retracting device is inserted to separate the lids. The cataract, an opaque degeneration of the human lens, is removed and a plastic lens is inserted in its place.

• **30** *Tumor Removal from the Inner Ear.* A tumor growing within the middle ear and adjacent to the cochlea of the inner ear caused progressive hear-

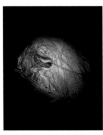

ing loss to this patient, a seventy-year-old woman. The tumor was seen in the CT scan to impinge on a facial nerve. To avoid further progression of the hearing loss and paralysis of the facial nerve, which would cause the unaffected side of the face to distort and skew, the tumor was removed.

• 33 *Craniotomy to Remove a Pituitary Tumor.* The pituitary gland secretes hormones that regulate many bodily functions, including, growth, reproduction, and various metabolic processes. A tumor, a spontaneous growth of tissue

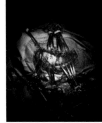

forming an abnormal mass, can wreak havoc with any of these and must be removed. In preparation for the removal of a massive tumor, the patient's head is secured in a vise that is attached firmly to the surgical bed. What looks like bundles of scissors are clamps used on the scalp to halt minuscule vascular bleeding.

• 34–35 *Surgery to Relieve Epilepsy.* What looks like a baseball is a head in a vise. The head had

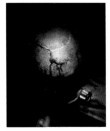

been shaved two weeks before in the first of a series of operations for severe chronic epilepsy. Patients diagnosed with severe chronic epilepsy have a lifelong illness with recurrent seizures that may occur as often as several times a day. They are usually unable to hold jobs, drive, or have any semblance of a normal life. This procedure was developed to eliminate or considerably reduce the number and frequency of seizures.

Based on the assumption that the region of the brain where the epilepsy originates no longer has a useful function, that function having moved to another part of the brain, a cortical excision, or lobectomy, is performed. A battery of neurological exams, including imaging studies and a Wada test, are done prior to any surgery taking place. During the Wada test, the left brain and the right brain are isolated and tested to locate motor function, speech, and memory.

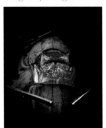

Surgeons must avoid these areas of the brain, but once the regions of the brain are safely identified, an initial surgery to locate the source of the seizure is performed. The cranium is opened

and an electrode plate is laid on top of the brain. With wires from the electrodes protruding out the back of the skull, the patient is returned to a room and hooked up to an EEG (electroencephalogram), used to analyze the electrical activity of the brain. Under twenty-four-hour video surveillance, the team and patient wait until the next epileptic event. By studying the EEG and the simultaneous video transmission, doctors are able to map the brain and reveal the exact site of the problem. Afterward, the cranium is reopened, the electrode plate is removed, and the lobectomy is performed.

• 36–37 *Wide Craniotomy.* To enter the brain to remove a brain tumor, the skull is opened (see page 47). Instead of using a hammer and chisel to crack open the skull, which would break the bone into jagged, uneven, irregular pieces, a special drill is used that works by pressure. Once it bores through to the other side of the bone, it stops. A good touch is indispens-

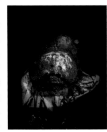

able, however, because the drill has been known on rare occasion to keep on going, entering the dura and underlying gray matter of the brain. After several holes are drilled, a special saw with a lip on the end that protects the jagged edge from cutting anything but bone is employed. Sawing from

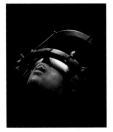

hole to hole, a geometric (in this case circular) portion of the skull is taken so that after the tumor is removed, the bone can be set back in place. Once the bone is extracted, the dura is painstakingly plied back layer by layer. The cerebellum exposed, the tumor lies even deeper. Without cutting portions of the brain, sections of the cerebellum are pushed aside to get to the site of the tumor. Donning something like a miner's helmet, the surgeon wears a fiber-optic lamp to illuminate the field of vision. Special magnifying glasses are used as well, giving the surgeon microscopic vision to operate deep into the innermost recesses of the brain. Using long, spaghetti-like instruments, the tumor is extracted piece by minute piece.

After the tumor is excised, the extracted portion of skull is sewn back into place. Patients remark postoperatively that they can occasionally feel the dime-size indentations under their scalp.

• 38–39, 108 *Pediatric Craniofacial Reconstruction.* This is the operation that

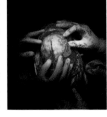

would have been done on the forty-one-year-old Crouzon's syndrome patient (see pages 16–23) had it been done in her childhood. Because the surgery is performed so close to the patient's brain, a neurosurgeon removes the skull and a plastic surgeon does the reconstruction. The skull is cut like a pie and secured with metal plates and screws, allowing the brain suffi-

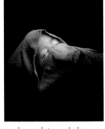

cient room for growth. Note the white globes at the top of the photograph on page 38: they are the patient's eyes. Before surgery (see page 108), during which the patient's scalp will be folded back over her eyes, her eyelids were sewn shut to prevent scratches or other accidental damage to the corneas.

• 41 *Cysticercosis.* A young woman contracted cysticercosis after eating a pork dish that was inadequately cooked. A parasite was ingested that settled in her brain, causing a cyst to develop that blocked the cerebrospinal fluid pathways. Before surgery, a crown called a stereotactic device was screwed into the patient's skull. The lower ring has lead points hidden inside and the top portion is designed to act like a sextant or compass. A CT scan was done with the stereotactic device locked on; afterward, the results were fed into a computer and the exact position, longitude and latitude, of the parasite plotted. The surgeon drilled a narrow hole exactly and precisely to the

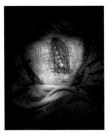

cyst and extracted it. Like a tumor or any foreign object in the brain, the parasite wreaked havoc with the normal physiological functions of the body. I witnessed the patient getting the CT scan prior to surgery; she was semiconscious, shaking uncontrollably, and had apparently lost a dangerous amount of weight. I called and spoke to the surgeon one day after the operation and found out she had improved dramatically and was well on her way to recovery.

TRUNK

• 42–43 *Closing the Chest after Lung Resection.* Emphysema caused by cigarette smoking had induced a portion of this woman's alveoli (the air cells of the lung) to blow up into large bubbles the size of gumballs, and as a result, she

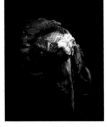

suffered a marked impairment in her ability to breathe. Part of the lung was cut out to reduce lung size. Contrary to expectation, removing a

portion of the lung improves breathing function. These photographs were taken after the resection was done. As in most thoracic procedures, a saw was used to divide the sternum and separate the two halves of the ribcage. Steel wire was used to sew the breastbone back together. The wound was irrigated with saline before closing.

• **45** *Heart Procured for Transplant.* This heart was rejected by the organ pro-

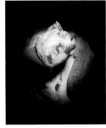

curing cardiac team at the last moment. A routine ultrasound revealed abnormalities in the muscle walls. The four valves of the heart were later salvaged. Valves, the membranous doors that direct the flow of blood by opening and closing with each heartbeat, can become defective, allowing the blood to flow backward, and thus need to be replaced.

• **46–47** *LVAD (Left Ventricular Assist Device).*

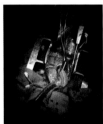

An artificial pump is sewn into the base of the diaphragm in the abdomen. Its tubing is connected to the heart, where it will assist in pumping blood through the left ventricle. Originally designed as a temporary solution for a patient awaiting a heart transplant, the LVAD pictured in this photograph was the first one installed in the United States as a long-term answer to a failing heart. Eighty percent of all the work the heart does sending blood to the body is performed by the left ventricle. With the left ventricular assist device taking over, the compromised heart is left in place and will function as if it were normal. The device is powered by a battery strapped around the patient's waist; the patient can resume most, but not all, normal activities (for example, he can play golf but can't swim). A spare battery is kept close at hand, and at night the patient plugs himself into a transformer next to his bed that not only supplies power but recharges his batteries. In case a battery fails, a hand-held pump is carried by the patient at all times. The LVAD, which was an offshoot of the failed artificial heart, took thirty years of research and design.

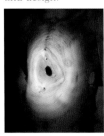

• **49, 10** *Pectus Excavatum.* An eleven-year-old boy had been born with a condition in which the ribs grow too long before birth. As they meet at the sternum, the ribs continue to grow and advance downward, placing undue pressure on the sternum and the heart. A CT scan revealed at one point that his heart had no more

than a 1-centimeter space to move in. An operation is performed in which the elongated ribs are cut, lifted up, and set into a normal position.

The procedure is frequently done when a child is about seven, but this particular patient was born in a prolonged delivery; forceps had to be used and as a result he has a moderate mental deficit. His doctor and family decided to wait until he was older and capable of understanding that the surgery was to help him and not hurt him. The coloring on the skin and what looks like a black hole is actually a Betadine wash, an iodine-based anti-infectant used to cleanse the skin. The Betadine pool at the epicenter of the sunken chest calls to mind the word *cups,* the

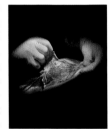

former terminology used in measuring the size and depth of this condition.

• **50–51, 52** *Breast Lift.* In preparation for cosmetic implants this thirty-year-old woman will have six months later, the skin surrounding her breasts is cut open like a pie. A portion of skin from each breast is removed, and the remaining pieces of the "pie" are sewn back together to make a firmer, less sagging chest.

• **53** *Breast Implant: Before and After.* A 180-degree cut is made along the lower base of the

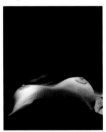

areola. The surgeon inserts his finger and rotates it 360 degrees to separate and break the subcutaneous tissue and thus make room for the prosthetic implant. He next inserts "test" silicone implants of various sizes to see which would work best. After choosing the right size, permanent implants are inserted into each breast, and the incisions along the two areolas are sewn shut.

• **55–56, 59, 112** *Modified Radical Mastectomy with Lymph Node Dissection.* This fifty-five-year-old woman diagnosed with breast cancer could have had a lumpectomy, with only the cancerous portion

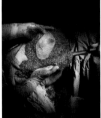

of her breast removed, but she chose to have a modified radical mastectomy instead. Had she chosen the lesser procedure she would have had to endure radiation therapy.

Generally, if a woman has a lumpectomy, the remaining breast tissue is irradiated to prevent local recurrence. Chemotherapy is given if there is tumor in the lymph nodes. If a mastectomy is done, no breast tissue remains, therefore no radiation is necessary. Radiation is a local treatment. Chemotherapy is a systemic treatment.

Modified radical mastectomy has replaced radical mastectomy as the most widely used surgical procedure for treating breast cancer. Besides causing less disfigurement than a radical mastectomy, it reduces postoperative arm edema (fluid collection in the tissues) and shoulder problems.

Specimens like lymph nodes (the ones located

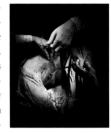

in the armpit) are preferably retrieved whole, intact, and connected to the primary tissue excised. Lymph nodes function as part of the immune response system. They may stop cancer cells, but in turn may become a metastatic site. Removing the entire breast with lymph nodes allows a pathologist to see if the cancer has metastasized (spread to other parts of the body).

In the photograph on page 56, the surgeon removes leftover skin, a "dog ear," hanging from the armpit, the result of removing a large mass of breast tissue.

• **60, 127** *Arterial Bypass.* A Dacron prosthetic artery is used to sidestep a buildup of plaque (atherosclerosis) in the aorta. The occluded section is bypassed (as opposed to being cut out) and will remain attached but unused. The prosthetic artery

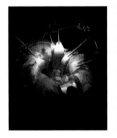

is in the shape of a Y, its two lower ends attached individually to supply blood to each leg. Patients feel an immediate result and benefit from this surgery, since they have not had blood flow freely to their legs and feet in years.

HARVEST

• **63** *Liver Transplant.* Three surgeons, the attending and two residents, prepare to close the abdominal cavity after a liver

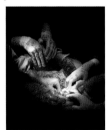

transplant. The intestines, which can be seen in the lower left of the photograph, undulate involuntarily and uninterruptedly as part of the digestive process in the phenomenon called peristalsis. During surgery, once freed from containment of the abdominal cavity, the intestines enlarge. Oc-

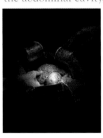

casionally, at the end of an abdominal procedure, there is difficulty in stuffing the intestines back inside the body.

• **64** *Cirrhotic Liver.* Compared to a normal liver, which among other characteristics has a soft and

smooth surface, cirrhotic livers, like the one in the photograph, take on a hard and wartlike texture. Cirrhosis can be caused by a variety of agents, including an overdose of acetaminophen (Tylenol), poisonous mushrooms, chronic alcoholism, congenital deformities and obstructions of the liver, intravenous drug use, viral infections (like hepatitis A, B, or C), bacterial invasion, and physical or chemical agents. Whatever the cause, cellular damage results in which the liver fails to perform many of its metabolic processes.

• **65** *Hepatoma.* A malignant tumor associated with liver disease — in this case hepatitis C — has grown to the size of a hand-

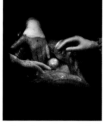

ball. The tumor was removed and a liver transplant was performed. Receiving a transplant is just the beginning of a process that will continue for the remainder of one's life. Recipients are required to take a combination of medications every day, among them immunosuppressant drugs such as Cyclosporine (a pharmaceutical derived from a fungal growth found in soil). Just as happens when any foreign object enters the body — a splinter, a virus, or a bacterium — the body's immune process will attack, fight back, and reject a transplanted organ or tissue. Immunosuppressant drugs serve to disarm the immune system. Once the immune system is disabled, however, the most common diseases can become deadly; thus a complement of daily doses of antibiotics and other prophylactic (preventive) drugs are prescribed. Note that the surgeon's hand on the right is double-gloved, a common precaution when operating on patients with infectious diseases. (Hepatitis B and C are contagious and carried in the blood.)

• **66** *New Liver.* After arriving at the hospital by air

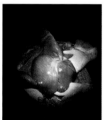

transport, a donated liver is sewn into the recipient.
• **67** *Liver Procured for Transplantation.* This healthy liver is of normal size, smooth in texture, and reddish in color (see cirrhotic liver for comparison, page 64).
• **68** *Lymph Nodes.* During an organ procurement procedure, the lymph nodes — the small nodules in the photograph — are retrieved from the mesentery, the peritoneal tissue encircling the greater part of the small intestine and connecting the intestine to the posterior abdominal wall. Varying in size from a pinhead to an olive, lymph nodes may occur singly or in groups and can be found also in

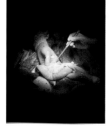

the neck and the armpit, as well as in the groin. Lymph nodes have two very important functions: they act as filters keeping particulate matter, especially bacteria, from gaining entrance to the blood stream; they also produce lymphocytes, a subgroup of leukocytes (white blood cells). Leukocytes are the primary cells that fight infection and disease. They not only neutralize or destroy organisms, but are also antigen specific. Antigens are markers on the surface of cells that identify the cell as "self" or "non-self." It is for this reason that they are critical in organ transplantation and are used as a means of tissue typing — comparing the donor (non-self) and potential recipients (self) — in order to avoid rejection.

• **69, 70** *Abdomen and Chest after Organs Have Been Removed.* The heart, liver, kidneys, spleen, and mesenteric lymph nodes have been procured for organ transplant. After

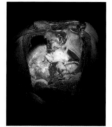

procurement (page 70), the flesh of the chest and abdomen is stitched together in a simple manner without the cosmetic treatment that would be given to a living patient.
• **72–73** *Skin Graft.* An elderly woman slipped and fell into a tub of scalding water, suffering second- and third-degree burns. The burned and scarred skin was shaved off with specially designed razor blades. A device not much different from the kitchen utensil used

to slice cheese was applied to remove a thin layer of skin three inches wide by eight inches long. So as not to remove more skin than necessary, the "graft" was processed through another machine at bedside that poked tiny holes in it, in essence meshing the skin so it could be stretched out to maximize the square-inch coverage.

Skin, considered a major organ just like the heart, liver, or eyes, is the largest vital structure of the body. Burns, as a result, cause a massive loss of fluid, a dangerously increased rate of metabolism, and the possibility of shock and risk of infection. A superficial burn covering a large part of the body is more serious than a small, deep one, unless important nerves and blood vessels are involved. If two-thirds of the skin is destroyed, death is likely.

X X & X Y
• **74, 76** *Laparoscopic Hysterectomy.* Carbon dioxide is used to inflate the abdomen to allow room for the laparoscopic instruments to maneuver. A small incision is made in the hidden recess of the navel, and an endoscope with a video camera is inserted. Additional small incisions are made for

inserting other surgical instruments. This noninvasive surgery was performed to remove the uterus and several fibroid tumors. The patient had extensive adhesions (fibrous

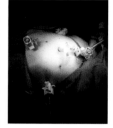

bands holding parts together that are normally separated), large fibroids (one the size of an abalone shell), and endometriosis (abnormal lining of the inner surface of the uterus). Because the specimens were so large, they were removed through the vagina.

As the bulbous tumor and elongated uterus were extracted through the vagina the surgeon remarked on the similarities between female and male genitalia. That they serve similar functions is obvious, but that they have similar structures has intrigued observers for centuries. The great Renaissance anatomist Andreas Vesalius considered the vagina and penis to be inside-out versions of each other, and he drew them this way in the *Fabrica,* the text that influenced anatomical teaching well into the nineteenth century. Even more astounding is the picture described by modern-day embryologists. At the sixth week of gestation, all human fetuses look identical and can potentially develop into females. Small blobs of tissue near the kidneys are the future gonads (sex glands) and are programmed to become ovaries. A small blob between the legs is destined to develop into a clitoris, labia, and vagina. But these default programs can be overridden if certain chemicals are present: a protein called TDF (testes determining factor) will direct the gonads to become testes, and DHT (dihydrotestosterone), a hormone produced by those glands, will cause

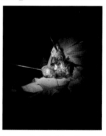

the genital blob to develop into a penis and scrotum. Instructions for making TDF are found on the Y chromosome, so typically only individuals with this chromosome develop into males. But given a mutated hormone, or the inability to respond to a hormone, individuals can be born with the gonads of one sex and the genitals of the other. Only after genetic testing do those supposed females find out they are carrying the XY chromosome and are, in fact, male.

• **77, 79–82** *Penile Implant.* He was sixty-four years old. The arteries of his penis had closed and impeded his ability to obtain an erection. Today he was receiving an implant, in fact, his second. The first was more than ten

years old. Over the years it, too, had failed, and now he was getting the best, the "Rolls-Royce," as the prosthesis salesman called it (see page 80) — little more than two cylindrical balloons that would be placed in the arterial

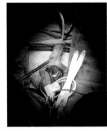

canals of his penis, some plumbing connected to a pump that would be hidden in his scrotum, and a reservoir filled with saline solution that would be implanted into his abdominal cavity. Though concealed in the scrotum, the pump has two distinct geometric regions that can be felt and identified when needed — a rounded ball and a square. Pumping the ball will bring the saline from the reservoir into the cylindrical balloons and make the penis rise. Similarly, pumping the square will lower the penis and return the saline solution to the reservoir. Having an orgasm, or the inability to have one, is a process determined by the nerves and not by the flow of blood. Physiologically, the inability to have an erection does not preclude the ability to have an orgasm.

The implementation of a prosthetic device for this type of impotence is a simple, if not elegant, solution. The same technology that can raise and lower the penis like a drawbridge has been modified to solve the horrors of incontinence — the inability to retain urine, semen, or feces.

• **1, 84–85, 87** *Cesarean Birth.* Moments after a birth by cesarean, an infant rests on his mother's abdomen, umbilical cord still attached. The enlarged and inflated testicles are due to a fluid ac-

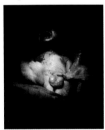

cumulation that will subside soon after birth. My first attempt to photograph a cesarean was unsuccessful. In my artist's mind, I imagined that the surgeon would make a long incision in the abdomen that would reveal the child asleep, his thumb in his mouth, lying in a fetal position, curled up in his mother's stomach. I daydreamed of this photograph and had it set in my head. The reality is and was altogether different. The preparation took some time, but once the surgeon pierced the uterus, the child was pulled out so quickly (to make him start breathing) that I was unable to stay focused or keep the baby in frame. I had to return a second time.

• **88–90** *Siamese Twins.* Four-day-old conjoined twins who shared a single umbilical cord, a bit of sternum, and abdominal muscle are separated in

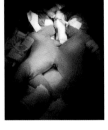

this operation. Although the complications of intubating and anesthetizing two individuals joined biologically took an hour and a half, of all the operations I have photographed this procedure was the shortest: from opening incision to separation the entire surgery took twenty-seven minutes. An additional fifteen minutes was required to close the wound on each child. A pediatric liver surgeon stood by and supervised the operation —a preoperative study was inconclusive and had led the surgical team to believe that the twins shared a single liver as well. They did not.

The uniqueness of their conjoined anatomies but separate circulatory systems is visibly present (see page 89) in the redness of the skin of the child on the right, whose body heated up during the operation in an adverse reaction to anesthesia. The children survived the separation and are living healthy, normal lives. Cosmetic surgery will be considered at a later date to give each child a navel of her own.

The term *Siamese twin* originates from the celebrated conjoined twins Chang and Eng Bunker (1811–1874), who were born in Siam (Thailand), and moved to the United States. Chang and Eng were never separated; they were married to two sisters in North Carolina, where they lived as gentleman farmers and fathered twenty-one children between them.

• **93** *Ovarian Cyst.* During the closing of the uterus (the left-hand side of the photograph) after a cesarean birth, the two operating surgeons

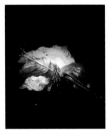

began speaking rapidly to each other in hushed whispers. Suddenly, what looked like an air-filled sack, a very large ovarian cyst (the right-hand side of the photograph) sprang out from the patient's abdomen. The patient was alert and conscious, having had an epidural, a form of anesthesia used when the patient needs to be kept awake during a procedure. One of the doctors spoke up and told her of the cyst. She remarked that two months prior to her pregnancy, it had been diagnosed and had measured the size of a peanut. In the ensuing eleven months, it had grown to the size of a grapefruit! She gave consent and it was removed.

• **94** *Retracting Tools: Hip Replacement.* What looks like a knife and fork are instruments for holding back the margins of the incision. The amount of fat encountered varies from one individual to the next. In a hip replacement, it can be as little as one half inch to as much as eight inches thick. The retracting tools are used to

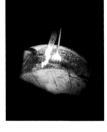

hold the wound open while the surgeon uses his instruments, much as a carpenter would use his woodworking tools. Orthopedic surgery is vigorous and muscular work. Saws, hammers, and chisels are the tools employed.

• **95, 96** *Hip Replacement in Progress.* The head of

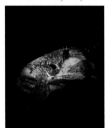

the femur has been sawed off and bone marrow has been removed to make room for a titanium post and ball. A part of the pelvis will be reamed away to allow implant of a metal cup with a plastic inner liner that will articulate with the metal ball to duplicate the ball-and-socket hip joint. The prosthetic joint may be either cemented into place or press-fitted so that the bone grows into the prosthesis. The skin is usually closed with staples.

• **97** *Hip Replacement.* Pieces of gauze are used to soak up blood and, once saturated, can be mistaken for human tissue. All surgical instruments, gauzes, needles, and threads are counted before making the initial incision and

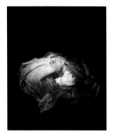

twice again at the end of the procedure before wound is closed to avoid leaving anything inside the body.

EXTREMITIES

• **98, 100–101** *Skin Graft: Hand with Deep Second-Degree Burns.* In a do-

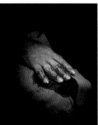

mestic dispute with his wife, a man suffered deep second-degree burns. The burned skin was removed and tissue was shaved from the thigh and grafted over the fingers. A skin graft is not only cosmetic, but decreases healing time and reduces the risk of infection.

• **103, 113** *Knee Replacement.* This surgery puts a steel-and-plastic joint in the leg to replace the natural one, typically crippled by arthritis. Like a carpenter's jig, the metal device surrounding the knee enables surgeons to make precise cuts into the damaged bone and cartilage. The jig is actu-

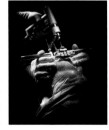

ally mounted on the bone to secure it while the cuts are made. A pneumatic drill is being used to insert a pin through the jig, thereby drilling the pin into the bone to hold the jig in precise alignment while the surgeon inserts

the pins that will hold the prosthetic device in place. Usually two surgeons will work together, constantly checking each other's work and refining each step of the procedure to insure that the prosthetic implant is as close to perfect as possible. The prosthetic joint must be precisely mounted to ensure smooth, natural motion of the knee.

• **104, 105** *Bone Procurement.* Bone grafts are

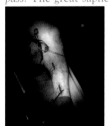

widely used though, except in autografts (self to self), donor bone cells do not survive. Instead, the grafts are used as structures upon which new bone cells from the recipient can grow, thus binding the strengthening skeletal defects until new bone is formed. Resection of malignant bone tumors and reconstruction by implanting composite bone and cartilage grafts can save extremities that might have had to be amputated. The photograph on page 105 shows PVC piping used to replace a donated tibia and patella after the bones were procured from the donor (see text page 61). The plastic knee joint and bone are installed in the leg to restore shape to the organ donor's body for burial.

• **106** *Bunionectomy (Removal of a Bunion).* A

bunion is a bone spur that grows on the joint below the big toe. It is more common in women than in men, due to high heels and pointed shoes. The condition can also be hereditary. A pneumatic oscillating saw is used to remove the bone spur.

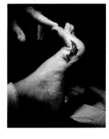

Once the bunion is removed, the surgeon checks the joint for function and mobility. Unique to operations on the limbs is the use of tourniquets to control the loss of blood. Time is critical. Surgeons work under a clock that runs backward to mark the remaining time.

• **107** *Procuring a Saphenous Vein for Coronary Bypass.* The great saphenous vein, extending from

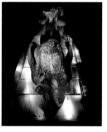

the foot to the upper part of the thigh, can safely be removed with no loss of function to the leg and to be used for coronary artery bypass surgery. Another possible conduit source is an artery called the internal mammary artery, a blood vessel that usually supplies blood to the chest wall. Either way, the plumbing of the heart can be rerouted and made to function at near-normal levels again. Surgeons believe that providing more new conduits to replenish the blood supply increases the chances of a successful long-

term outcome. This is the reason for triple, quadruple, and even quintuple bypasses (referring to the number of new conduits created). The number of bypass grafts does not necessarily indicate the severity of the disease.

• **111** *Pallidotomy.* For certain types of Parkin-

son's disease, a surgical remedy exists. With the patient conscious, a hole is drilled in the skull and a hollow probe is passed to the globus pallidus, where the disease is known to originate. What looks like a painful scream is ac-

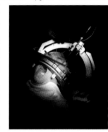

tually a painless motor function test — necessary to the procedure — in which the patient is asked to open and close his mouth. To find the exact location of the area within the globus pallidus to be destroyed, a microelectrode is hooked up to an oscilloscope and a speaker is inserted inside the probe into the globus pallidus. As the electrode nears the targeted site, the electrical activity of the brain cells can be seen on the scope and heard over the speaker firing at an intense and erratic rate. The globus pallidus is the site at which the nerves that come from the substantia nigra produce dopamine, a biologically active compound that acts as a neurotransmitter. In the case of Parkinson's disease, it has dried up and ceased to generate the naturally occurring dopamine. A depletion of dopamine produces the symptoms of rigidity, tremors, and bradykinesia (extreme slowness of movement) that are characteristic of Parkinson's disease. Levodopa, a dopamine precursor, is given as medication, but after prolonged use, it ceases to work. The surgery reduces the hyperactivity of the globus pallidus, reinstates its natural cellular rhythms, and makes it receptive again, enlarging the window for receptivity to medication. There is an almost immediate result for even the most severe case of rigidity and tremors. Patients are known to begin walking at once.

• **114** *Pediatric Neurosurgery.* A paralyzing tumor three inches long was located inside the top of the child's spinal cord, culminating in a golf ball–sized mass inside the brain stem. To reach the tumor, the spinal cord had to be sliced open. This kind

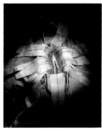

of surgery would never be performed on an adult, since the ensuing paralysis would be permanent; however, on a child who is growing, the severed nerves can sometimes actually reconnect and heal. Because of the extreme insult of this kind of surgery to the central nervous system, a special team of physiologists must be

present inside the operating room monitoring every aspect of the patient's functions. One small slip and the patient may die.

• **116, 123** *AIDS Autopsy.* Although acquired immunodeficiency syndrome (AIDS) is not a surgical disease, I wanted to memorialize the plague of my generation. I imagined that the lesions I often associated with AIDS would have obviously attacked the internal organs as well as the exterior of the body and would be demonstrably evident. Though the man I photographed had AIDS, he did not have the cancer, Kaposi's sarcoma, the cause of the lesions I associated with AIDS. AIDS, as the name infers, is a breakdown of the immune response to disease. As a syndrome, AIDS encompasses numerous disease processes, such as pneumonia, viral infections, and cancer. The patient I photographed had none of these. His death was abrupt and unexpected. The day before his last breath, he became acutely psychotic and ultimately went into cardiac arrest. The autopsy was performed to find an explanation for his psychotic behavior and sudden premature death. As part of the evisceration, the tongue was removed —

it can be seen in the photograph on page 116 lying atop the larynx before it was excised. It is routine to remove the tongue to look for oral cancer or "thrush" (especially in HIV-positive cases); it is also helpful to look for amyloid deposits on the tongue if there is a suspicion of amyloidosis, a systemic disease. His brain (page 123) was of primary interest to the pathologists, but as is routine in a complete autopsy, all internal organs were removed and examined.

The procedure was done in a small room set aside just for autopsies of patients with AIDS and other blood-borne or airborne infectious diseases (hepatitis or tuberculosis, for example). The diener (lab assistant) wore a negative pressure mask to avoid breathing in contaminated air, and both she and the pathologist were triple gloved, with two layers of latex and an outer glove made of chain mail.

• **7, 128** *Laser-Assisted Surgery to Correct Nearsightedness.* An excimer laser is used to reshape the cornea. After surgery, patients are able to discard their glasses. Rarely does medicine and surgery have the ability to realize real cures; at most, prolonging and improving the quality of life is the best that can be obtained. Laser-assisted eye surgery to correct nearsightedness is one procedure in which the results are as immediate as they are effective.

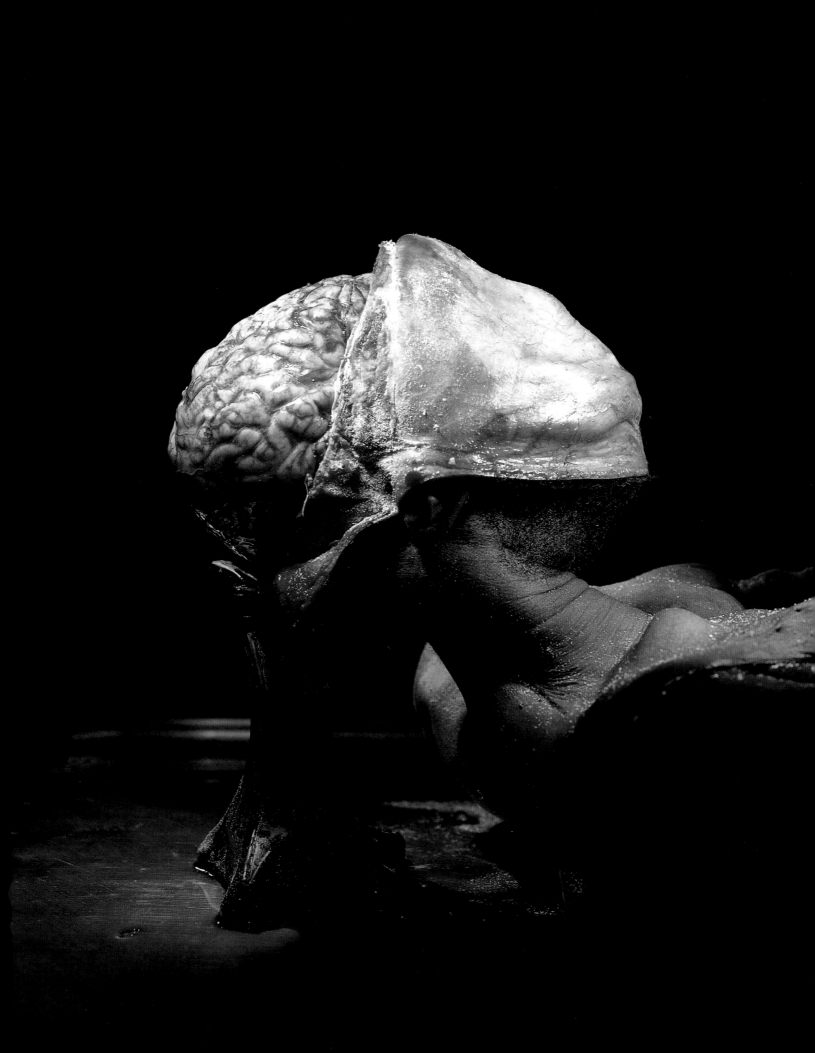

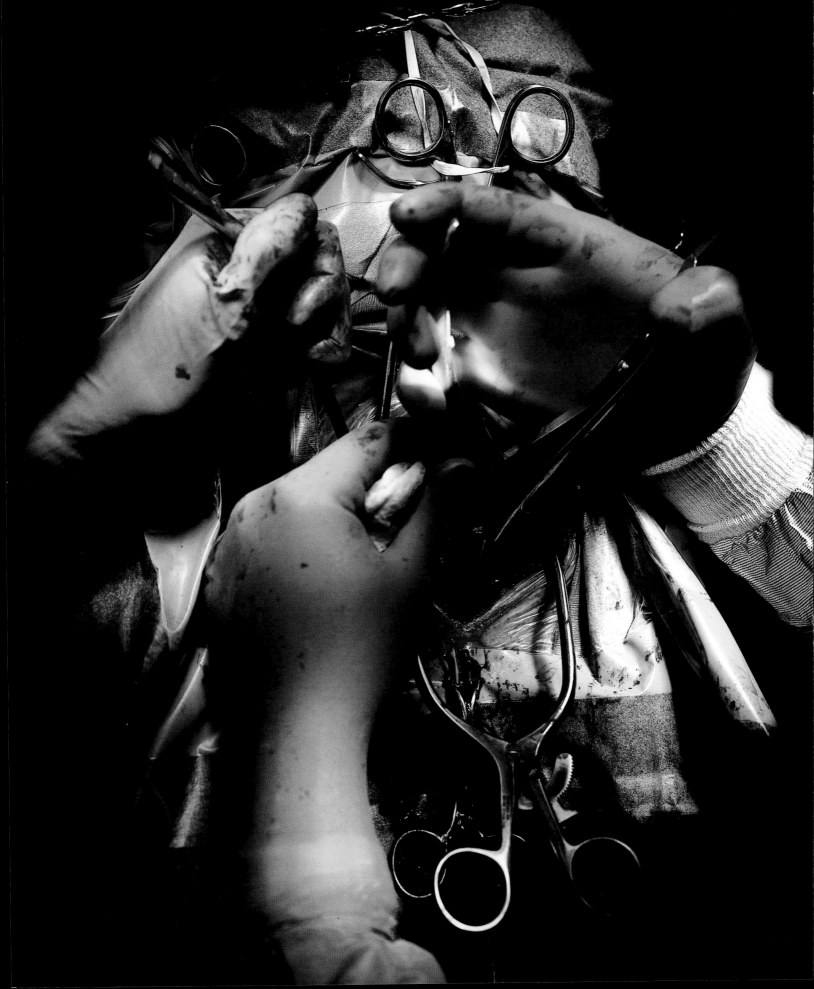

ACKNOWLEDGMENTS

This project was eight years in the making. Along the way I had the help of many individuals. These few words cannot begin to describe my gratitude. Where do I begin?

In the beginning there was Gina Davis, who hired me to photograph Dr. Frances Conley, an act which not only led to the conception of this book, but changed my life forever. If it were not for Dr. Conley, who let me peer into the infinite, these words and photographs you hold in your hands would not exist. It was my sister, Dolores Metzner, who had the insight to suggest I do a book in the first place. Early on I met Laura Lindgren, who produced the Mütter Museum calendars, and Ken Swezey, who were among the first to recognize the value of these photographs and have been their champions ever since. Daniel Roebuck believed in them from the onset, introduced me to Sarah Lazin, and found me work so I could support myself and fulfill my dreams. His influence and vision are evident in this book and remain with me to this day. Sarah guided me from the original handful of photographs and shepherded this project for the next seven years. Then, with unfailing determination, she found a publisher as well. Nancy Ascher, M.D., was the first surgeon to understand what I was attempting to do. She was the first to collect the photographs and introduced me to the books of Richard Selzer, M.D., when I needed them. Reading Selzer's *Confessions of a Knife* brought me solace. To realize this road had been paved by others, to know it was permissible to look at the body, to see anatomy as metaphor, was liberating and gave me the courage to continue. To have Richard Selzer write the introduction is not only fitting, but a great privilege. I also want to thank John Elefsteriades, M.D., at Yale, who introduced me to Selzer. And to A. D. Coleman my appreciation for the love of photography he inspired in me as a young man and for the largesse of his afterword.

There were several conduits through which I entered operating rooms: the public affairs offices of hospitals, word of mouth — one doctor telling another — and a more traditional route, editorial assignment. Laurel Joyce at *Stanford Medicine*; Michael Fitzsousa at *Yale Medicine*; Richard Boddy at *Discover*; Trip Mikitch at *Parenting*; Kathy Ryan of the *New York Times Magazine*; Greg Ponds at *Details*; Guy Martin, Margie Goldberg, and *New York Magazine*; Michelle McNally and Alex Colow at *Fortune*; Jane Palecek, Dorothy Marshall, and Teo Furtado at *Hippocrates* gave me assignments that allowed me to meet surgeons and gain entry into their operating rooms. Nisa Geller and John Renny at *Scientific American* assigned me as well and then fought and persevered to publish some of these photographs as a portfolio in the magazine. David Armario not only gave me assignments at *Stanford Medicine* and *Discover*, but helped me put together the original body of this work.

I was taken in, succored, and given every opportunity by Deborah Bangledorf, Joe Martin, Marc Kusinitz, Michael Purdy, Michele McFarland, and Chris McKee-Sloat at the Johns Hopkins. Rochelle Lazarus and Shelly Rosenstock extended me the privilege of working at Englewood Hospital in New Jersey. Laurence Swasey and Mariam Perez, R.N., of the New York Regional Transplant Program, spent more than one very long night with me so I could photograph a most singular and phenomenal gift of human charity. I met John Persing, M.D., and Maryanne Baer-Hines, R.N., M.S.N., Clinical Coordinator, Yale Craniofacial Center, at the very end of this project; their time, generosity, talents, and skills allowed me to take the photographs that have rounded out this book and project. I am deeply indebted as well to Alison Estabrook, M.D., and Mehmet Oz, M.D., at Columbia-Presbyterian for their trust and confidence.

I would also like to thank David Cohan and the Pre-Medical Association of Columbia University, who organized a lecture and presentation of this work at Columbia University, the process of which forced me to organize my thoughts and reveal these photographs to the public for the first time. I must also thank Rose Shoshana, the Gallery of Contemporary Photography, Rip Georges, Laurence Gonzales, and John Strausbaugh; Carol Squiers at *American Photographer*, Daryl Turner at *Art Forum*, and Larry Frascella at *Photo Design*. I wish to thank Joanne Hoffman and Linda Ferrer for the honesty of their comments. A special thank you to Socrates Karally, Rose Ravid, and Joyce Ravid. I want to thank Owen Edwards for his criticism, enthusiasm, and insight. This project could not have been completed without the encouragement and support of Nestor Rodriguez, Matthew Suarez, and Michael Shuster.

I am indebted to John Edsall, M.D., a senior physician at Columbia-Presbyterian, and Andy Chiou, M.D., a chief surgical resident at the New York Hospital–Cornell Medical Center, who read the text. Their friendship, advice, and support have carried me a long way. A special thank you to Dr. Deborah Mowshowitz and Dr. Judith Gibber at the Department of Biological Sciences, Columbia University, who answered some very specific questions on genetics, and to Will Rosenblatt, M.D., at Yale School of Medicine, who read the sections pertaining to anesthesia. I was fortunate to have the suggestions of Rick Moody and Mary Agnes Edsall, who read the text as well.

Over twenty years ago, Tony Lane hired me at *Rolling Stone* as an apprentice printer in the photo department and became my mentor. It was providential, if not cathartic, to have Tony design the book — the impact he made having as much to do with his sense of design and editorial discernment as it does with his journey as an artist and human being. I also want to thank Eric Kaltman and the Queens Group for their support. I want to thank Janet Bush, Ken Wong, Betty Power, and Carol Judy Leslie at Bulfinch Press. They not only had the courage to publish this book, but have gone to extra lengths; the guidance and the freedom they gave me made this book more than I ever dreamed of.

THE SURGEONS

Nancy Ascher, M.D., Ph.D., Chief, Liver Transplant Service, University of California at San Francisco Medical Center

Benjamin S. Carson, M.D., Director of Pediatric Neurosurgery, Johns Hopkins Children's Center

Noel L. Cohen, M.D., Professor and Chairman of Otolaryngology, New York University Medical Center

Paul M. Colombani, M.D., Director of Pediatric Surgery, Johns Hopkins Children's Center

Frances K. Conley, M.D., Professor of Surgery, Stanford School of Medicine; Chief of Neurosurgery, Veterans Administration Medical Center, Palo Alto

Herbert Dardik, M.D., F.A.C.S., Chief, Vascular Surgery, Englewood Hospital and Medical Center

Gerardo Del Zalle, M.D., Obstetrics/Gynecology, University Hospital, Albuquerque

Fred J. Epstein, M.D., Chairman, Department of Neurosurgery, Beth Israel Medical Center

Alison Estabrook, M.D., Chief, Breast Service, Columbia-Presbyterian Medical Center

Mark Ginsberg, M.D., Thoracic Surgery, Columbia-Presbyterian Medical Center

Roberta Glick, M.D., Attending Neurosurgeon, Cook County Hospital; Associate Professor of Anatomy and Cell Biology, University of Illinois

J. Alex Haller, M.D., Professor Emeritus, Pediatric Surgery, Johns Hopkins Children's Center

Gary Heit, M.D., Ph.D., Neurosurgery, Stanford University Medical Center

Grover Hutchins, M.D., Director of Autopsy Pathology, Johns Hopkins Hospital

Bruce Jackson, C.T.B.S., C.S.T., New York Regional Transplant Program

Michael Madden, M.D., Clinical Director of Burn Unit, New York Hospital–Cornell Medical Center

Frank Moore, M.D., Neurosurgery, Englewood Hospital and Medical Center

Camran Nezhat, M.D., Clinical Professor of Surgery, Obstetrics/Gynecology, Stanford University Medical Center

John K. Niparko, M.D., Director of Otology, Neurotology, and Skull Base Surgery, Johns Hopkins Hospital

Walter R. O'Brien, M.D., Orthopedic Surgery, Saint John's Hospital and Health Center, Santa Monica

Mehmet Oz, M.D., Cardiothoracic Surgery, Columbia-Presbyterian Medical Center

John Persing, M.D., Professor and Chief, Section of Plastic Surgery, Yale School of Medicine

Eric Rose, M.D., Cardiothoracic Surgery; Chairman, Department of Surgery, Columbia-Presbyterian Medical Center

Oliver D. Schein, M.D., Associate Professor of Ophthalmology, Johns Hopkins Wilmer Eye Institute

Stephanie Schreiner, M.D., Pathology, Johns Hopkins Hospital

Gerald Silverberg, M.D., Neurosurgery, Stanford University Medical Center

Mark G. Speaker, M.D., Director of Corneal and Refractive Surgery, New York Eye and Ear Infirmary

Richard N. Stauffer, M.D., Professor and Director of Orthopaedic Surgery, Johns Hopkins School of Medicine

Abe Steinberger, M.D., Neurosurgery, Englewood Hospital and Medical Center

Craig A. Vander Kolk, M.D., Pediatric Plastic Surgery, Johns Hopkins Children's Center

Gary Wasserman, M.D., Urologist, Englewood Hospital and Medical Center

I am deeply grateful to the surgeons, nurses, residents, anesthesiologists, and most of all, the patients,
who in their pain, suffering, and hope allowed me the privilege of photographing their afflictions,
the interior of their bodies, if not their very souls.

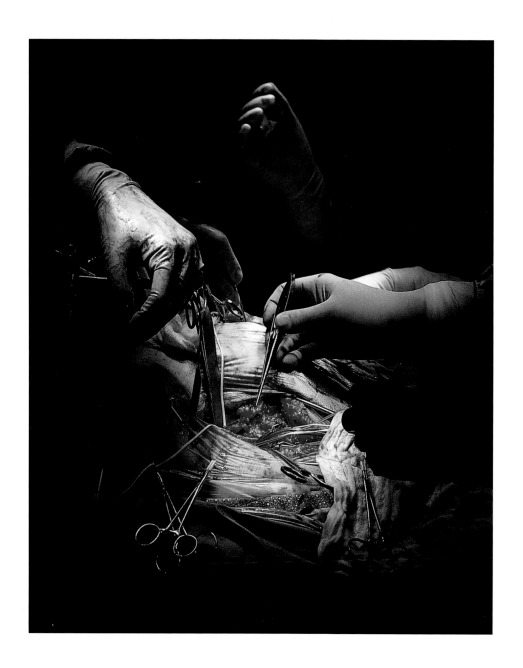

The photographs were taken with an Ebony SV45 Field Camera

on a Gitzo 500 tripod with a Nikkor-W 180 lens and a Prontor shutter

on Fuji Provia Quickload film using a Polaroid back.

The prints were made by Beth Schiffer in New York City.

The scans were made directly from the 4" x 5" original transparencies

by Rich Browers, El Sereno Graphics, in Los Angeles.

The typeface is Goudy Old Style. Printed by South China, Hong Kong.

The book was designed by Tony Lane.